IMAGES
of America

NORTHERN CALIFORNIA'S
LOST COAST

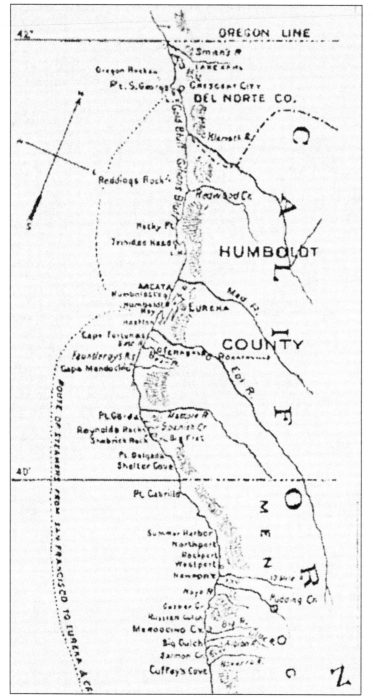

This book covers the Lost Coast from Ferndale south to Westport. This 1881 map, from *The History of Humboldt County* published by Wallace W. Elliot & Company, shows the coast from San Francisco to Eureka. It illustrates the small inlets where ships would stop, as well as the Eel and Mattole Rivers. (Author's collection.)

ON THE COVER: Taken March 1, 1898, at Cape Mendocino, this image offers a glimpse of the Lost Coast. Cape Mendocino, the westernmost point in California, has been a landmark for sailors since the 1500s. Numerous sea caves exist along the coast in both Mendocino and Humboldt Counties. (Kelley House Museum.)

IMAGES
of America

NORTHERN CALIFORNIA'S
LOST COAST

Tammy Durston

ARCADIA
PUBLISHING

Published by Arcadia Publishing
Charleston, South Carolina

Printed in the United States of America

Library of Congress Control Number: 2016954034

For all general information, please contact Arcadia Publishing:
Telephone 843-853-2070
Fax 843-853-0044
E-mail sales@arcadiapublishing.com
For customer service and orders:
Toll-Free 1-888-313-2665

Visit us on the Internet at www.arcadiapublishing.com

This book is dedicated to my grandparents Edmund Durston and Leila Zimmerman Durston, who were teachers at Fortuna High School from 1919 to 1921; David; and my kids Max, Alex, and Chloe.

CONTENTS

ACKNOWLEDGMENTS

I was very fortunate to have some wonderful assistance with this project. First, I would like to thank Caitrin Cunningham, my title manager at Arcadia Publishing, for her patience and guidance. In regards to the book materials, I would like to thank Laura Cooskey at the Mattole Valley Historical Society for her generosity and knowledge of the area. This project could not have been completed without her help and guidance. Greg Rumney, who collects old photographs, was also extremely helpful with sharing images and helped me with his knowledge of the area. Anne Cooper and Ray Duff of the Kelley House Museum in Mendocino were great with helping me identify and copy photographs. Thanks go to them and their wonderful organization. The staff and volunteers at the Humboldt County Historical Society opened their doors to me, and I appreciate that very much. Humboldt State University also provided very valuable assistance by sharing photographs. I would also like to thank Rachel Sowards of the Bureau of Land Management (BLM) in Whitethorn for her help with information about Punta Gorda. The Bancroft Library at the University of California at Berkeley provided some valuable photographs for me too. The area is very fortunate to have such wonderful local historical organizations that preserve and document the region's history.

INTRODUCTION

What is the Lost Coast? Although most locals do not use this term, the Lost Coast refers to a region of the Northern California coastline that has remained relatively untouched. The Lost Coast encompasses a portion of two counties: the northern coast of Mendocino and the southern coastline of Humboldt. This area is the wildest and least traveled part of California's entire shoreline. It is known for steep mountains rising quickly above the sea, empty beaches, grassy meadows, and dense forests. Once populated by Native Americans, the Lost Coast is now predominantly park and conservation wilderness land.

When the highways were first built, Highway 1, which traditionally hugs the California coastline, had to be moved inland due to the difficulties highway engineers had trying to design the road along the coast. Even today, there are few access points to the ocean by car. Small towns in the area, such as Petrolia, Honeydew and Shelter Cove, remain isolated today.

The first inhabitants were Native Americans. It is estimated there were more than 15,000 living in southern Humboldt and northern Mendocino Counties. The Soo-lah-te-luk (Wiyots) lived from Humboldt Bay south down to below the mouth of the Eel River. Near the Bear River to the coastline, the Nek-an-ni (Bear Rivers) lived. To the immediate south were the Be-tol or Pe-tol (Mattoles). Further south were the Sinkyones and the Coast Yukis. Bountiful plant life, with redwoods, tan oaks, and Douglas fir, coupled with food from the ocean and rivers created an atmosphere ideal for sustaining life. Native Americans grouped themselves by language, not by the concept of a "tribe." Within each group, there were also villages. Early white settlers came up with names for these groups that sometimes sounded like the names of the languages; sometimes, they did not.

Harsh weather on the seas kept many early explorers away from the area. There were more than 50 shipwrecks on the Humboldt and Mendocino coastline from 1850 to 1900. Early European explorers quickly learned that the ocean on the Northern California coast was deadly. Fierce storms combined with reefs offshore caused shipwreck after shipwreck. Landings were also problematic due to the rocky shores. Eventually, Spanish explorers turned around after reaching this part of the California coast. Although the Russians built an outpost to the south at Fort Ross in the early 1800s and there were settlements in Humboldt Bay, the Lost Coast remained unexplored until around 1850.

Early land explorations were also hindered by the mountains, and expeditions avoided the area. The Gold Rush changed everything though. As more and more explorers and would-be gold miners flocked to California, explorations were not limited to the areas near goldfields. Most early accounts document that at first, Native Americans greeted the new explorers in a friendly manner, wanting to trade. However, this changed as settlement grew. White settlers began to homestead on Native American land. The Native Americans' way of life was dismantled, and they no longer could roam for food. Skirmishes ensued. Not only were the Indians displaced, they were denied resources for survival. The conflict grew into a war and most tribes were wiped out. By 1862, almost all Native Americans that were left were rounded up and placed on reservations.

Many of the new settlers came to California for gold, but quickly discovered the timber. The timber industry remained dominant until the supply was depleted. Cattle, sheep ranching, and dairies were well suited to the land. After the timber industry wound down, the area became depopulated, which contributed to the term "Lost Coast." Then, during the 1970s, most of the coastline was converted to parkland. In 1970, the King Range National Conservation Area was formed. Consisting of more than 68,000 acres, the King Range spans 35 miles of the coastline. From Shelter Cove south to Usal is Sinkyone Wilderness State Park. The Lost Coast Trail was developed during the 1970s. It begins at the Mattole trailhead in Humboldt County and ends at Usal Beach in Mendocino County. Thousands of hikers make this trek each year.

This book chronicles from the small town of Westport in Mendocino County north to Ferndale in Humboldt County. The focus is the history of the area and some of the settlements and towns that no longer exist. The book is divided into three chapters: a brief history with a focus on indigenous people, the Northern section of the Lost Coast from Ferndale south to Shelter Cove, and the Southern section from Shelter Cove south to Westport. The author has purposely taken an expansive view in order to showcase the history of this important area through glimpses of historical photographs. The book is an incomplete history due to necessary restrictions but hopefully it will encourage you to explore the history of the area.

I grew up hearing about the wonders of Humboldt County from my grandparents. They met as teachers at Fortuna High School in 1919. Eventually, they married and moved out of the area. But they always loved the area and told me many stories about their life. Some of my grandfather's photographs from that time period are included in this book.

To support local history, all profits from the sale of this book will benefit several local historical groups, in particular the Mattole Valley Historical Society, the Kelley House Museum, and the Humboldt County Historical Society.

One

HISTORY AND
EARLY INHABITANTS

The Lost Coast is truly the last remaining stretch of undeveloped land in California. Native Americans lived in the inland valleys and sometimes along the coastline. Those who lived inland traveled to the coast for seasonal food. Now, the area is primarily known for the Lost Coast Trail, which follows the coastline from the mouth of the Mattole River to Usal. Charles Nordhoff, in his article *Northern California 100 Years Ago*, published in *Harper's*, writes this about the Northern California coastline: "You will see, in Mendocino County, one of the most remarkable coasts in the world, eaten by the ocean into the most singular and fantastic shapes . . . you descend from what appears to you an indeterminable mass of mountains suddenly into a plain, and pass from deep forests shading the mountain-road at once into a prairie valley, which nature made ready to the farmer's hands, taking care even to beautify it for him." This photograph showcases the terrain that characterizes the Lost Coast. (Author's collection.)

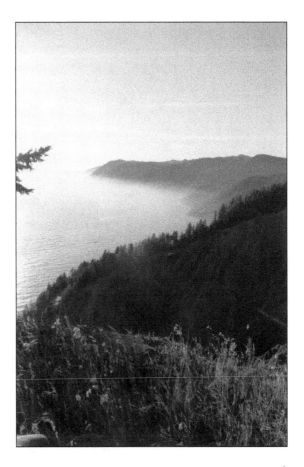

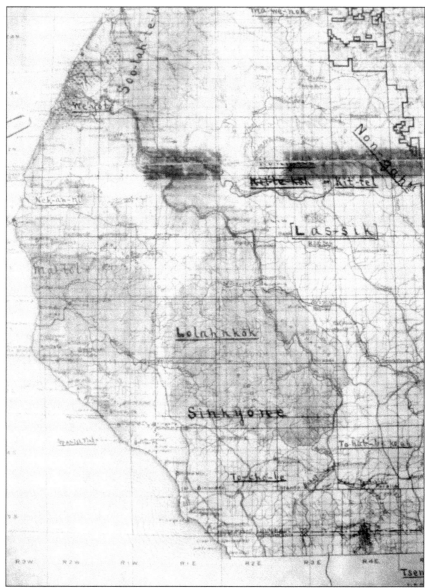

Many Native Americans lived in the Lost Coast area for thousands of years before European explorers and white settlers arrived. Plentiful acorns and abundant salmon created an environment where they could thrive. Native Americans divided themselves by language. The common term "tribes" was invented by Europeans and not used by the Native Americans themselves. The Athabascan-speaking groups occupied almost the entire southern and eastern parts of what is now Humboldt County. According to *Two Peoples, One Place* by Ray Raphael and Freeman House, there were more than 20 different groups in this region, with several variations between them. For example, in the north, the Athabascan culture was similar to that of the Pacific Northwest Indians with their dependence on salmon. In the south, Native Americans were more aligned with the central California cultures and their use of acorns. Along the Lost Coast, the groups from north to south included the Wiyots, the Bear River Mattoles, the Mattoles, the Sinkyones, and the Coast Yukis. This map shows groups by language. (Mattole Valley Historical Society [MVHS].)

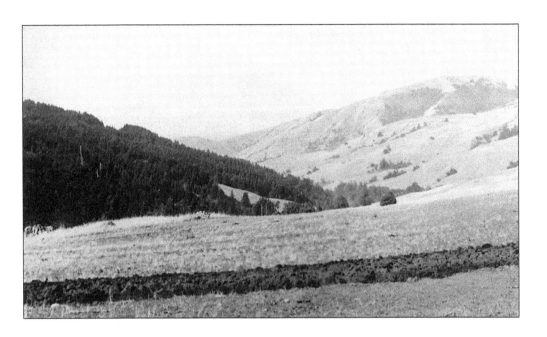

The Lost Coast is comprised of mountains, meadows, and the sea. The mountains rise in elevation very quickly from sea level, which creates very steep, jagged cliffs. Tucked between the two are meadows and small valleys. Native Americans managed the land in various methods, such as cultivation, pruning, selected harvesting, as well as planting. The above photograph shows the prairie and mountains in the Cooskie Range. The photograph below is of the coastline near Cape Mendocino. (Above, MVHS; below, Humboldt State University.)

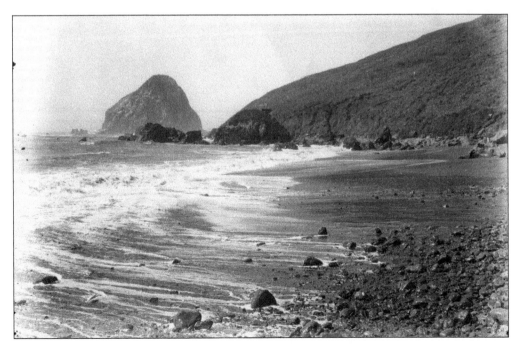

Salmon was one of the staples of Native American diets. The seasonal salmon run often involved ceremonies called the first-run salmon rites (Sinkyones.) During the salmon run, the entire village would camp along the river. This photograph was taken in 1923 by photographer Edward Curtis. (Library of Congress.)

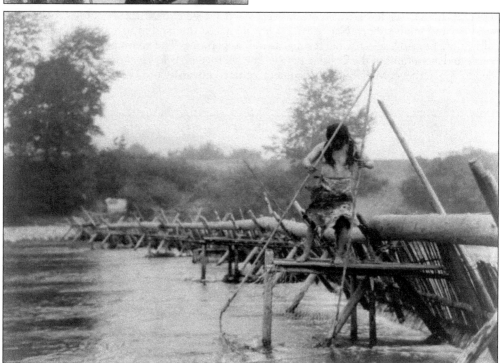

Fishing weirs were used by the Bear Rivers and the Mattoles. Although this photograph is of a fishing weir on the Trinity River, the design is similar to what was used. A very important component of the weir was the cordage. Fibers of the wild iris were considered to be the strongest. Some weirs were fixed and some were handheld. The Mattoles used fixed weirs to catch salmon. (Library of Congress.)

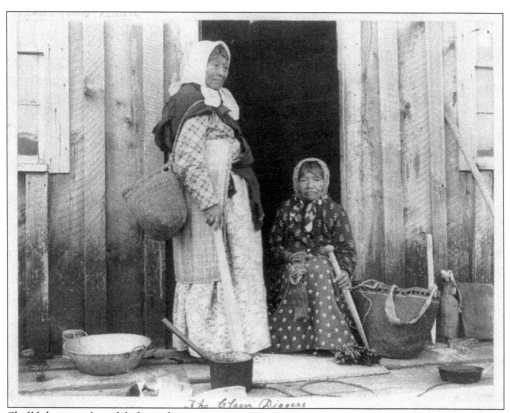

The Clam Diggers

Shellfish were plentiful along the coast of Mendocino and Humboldt Counties. This is a photograph from 1894 of two Wiyot women preparing for clam digging. Razor clams are plentiful on the North Coast. (Library of Congress.)

Acorns were tremendously important for many Native Americans. A large oak could yield 500 to 1,000 pounds of acorns per season. Tan oak acorns were the preferred type, but the Indians used what was available. The basic steps in preparing acorns are drying, grinding, leaching, and cooking. This photograph from 1924 shows a Pomo woman cooking acorns. (Library of Congress.)

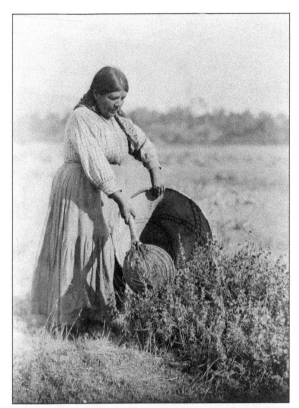

Baskets were an essential item for daily duties, ranging from gathering seeds to food storage to carrying children. Many other plants contributed to the Native American diet, from huckleberries to manzanita and madrone fruits. Various grassland seeds were ground into pinole. Plants were also widely used for medicine. The Sinkyones used Sitka spruce and coast redwood fibers for baskets. (Both, Library of Congress.)

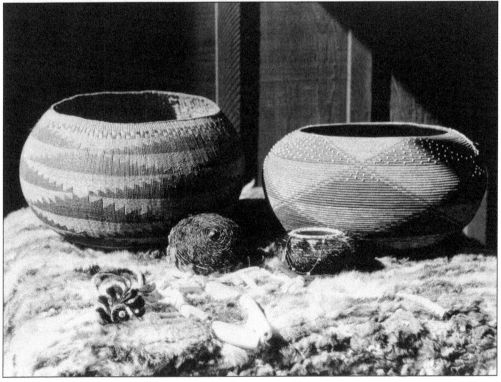

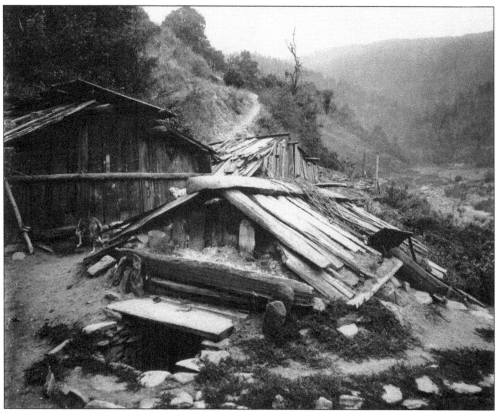

Housing varied by Native American group. The Mattoles, Bear Rivers, and Sinkyones had wedge-shaped structures, almost like lean-tos. In the northern area, planks were used after being split with elk horn wedges. Temporary houses were also excavated and constructed out of brush in a circular fashion with a center beam and used during the hunting season. They were abandoned after the season ended. These homes are similar to central California Indian dwellings. Sweathouses were also constructed. The above photograph shows a typical home; the photograph below shows a later version using planks, as well as white and European influence. (Above, Humboldt State University; below, MVHS.)

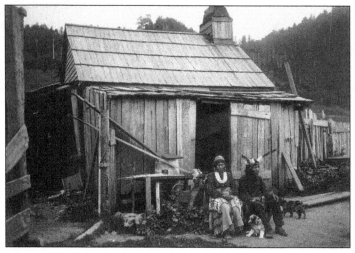

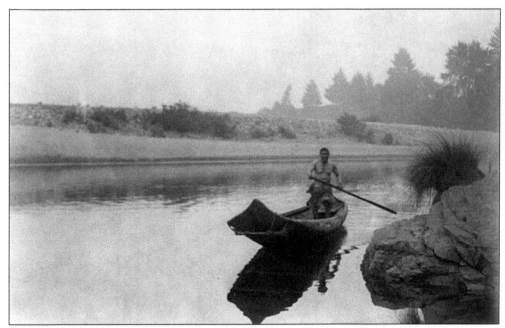

Many Native American villagers lived by the Eel River and traveled on it by canoe. The redwood canoe was very important. Not only did it offer transportation, but it also allowed access to waterways such as the Eel River, pictured below, and to the sea for food. Trees were considered living spirits and were not treated lightly. It would take up to a year or two to make a canoe by hollowing out the insides. Although this photograph is of a Hupa canoe, the Native Americans in this area constructed them similarly. Some of the earliest sightings of Native Americans by European explorers were of them on canoes. If the ocean was mild, canoes were taken out on the sea by the Sinkyones in search of seals and sea lions. (Above, Library of Congress; below, author's collection.)

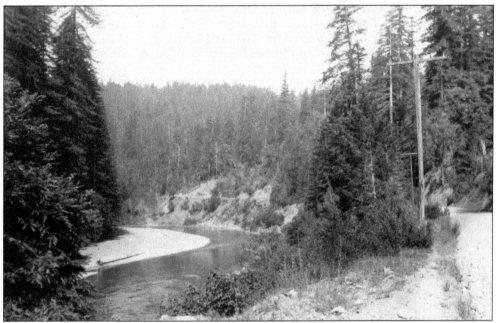

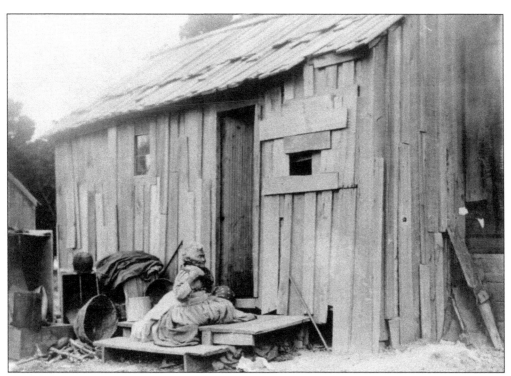

Pliny Goddard, Edward Curtis, Alfred Kroeber, C. Hart Merriam, and Gladys Ayer Nomland are some of the well-known researchers who documented Native Americans in the northern Mendocino and southern Humboldt areas. Traditionally, Native American history was stored orally. Interviews were conducted and photographs were taken to document lives. Emma Belle Freeman was a photographer who moved to Eureka in 1910 and specialized in photographing Native Americans. Freeman did stage her settings for her photographs, but she created accurate settings. She compiled her photographs in several books, including one called *Northern California Series*. (Both, Humboldt State University.)

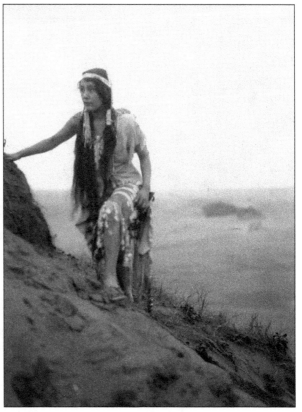

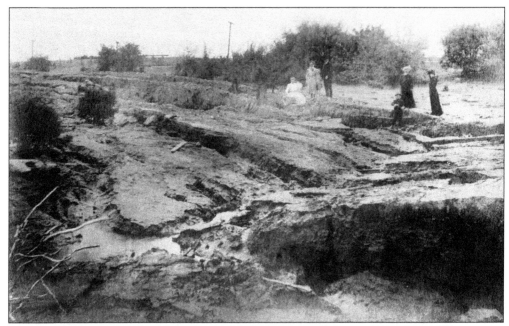

The Lost Coast is one of the most seismically active areas in the state of California. Three major fault zones meet between Cape Mendocino and Punta Gorda, at the Mendocino Triple Junction. This photograph shows the aftermath of the 1906 earthquake near Ferndale. (Greg Rumney.)

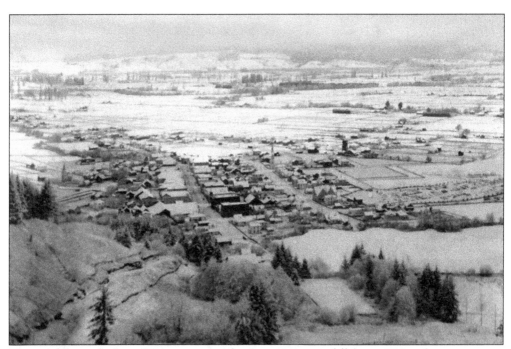

The weather on the Lost Coast can range from extensive rainfall (up to 200 inches in one year and sometimes over a foot in one storm) with harsh wind to warm summers inland. There have been instances of snow even at lower elevations, as seen in this undated but early photograph of the Eel River valley and Ferndale. (Greg Rumney.)

18

The Mendocino and Humboldt coastline was a very tough area to explore due to offshore rocks and harsh weather that contributed to shipwrecks. According to *Shipwrecks of the California Coast*, by Michael D. White, there was an average of 10 ships lost each year from 1887 to 1897 from Point Arena to Humboldt Bay. Early explorers and trappers on expeditions in the area were hindered by the mountains of the Lost Coast and tended to avoid the area. The early explorer L.K. Wood, who published *The Discovery of Humboldt Bay*, describes the redwoods near the coast as a "dismal forest prison." (Right, David Rumsey maps; below, Library of Congress.)

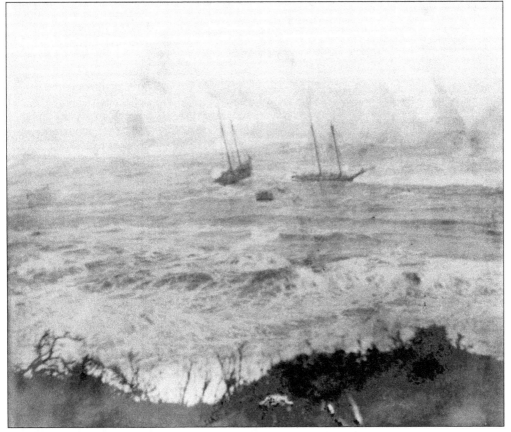

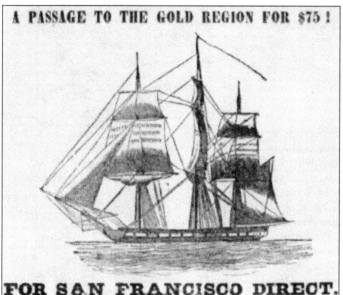

A PASSAGE TO THE GOLD REGION FOR $75 !

FOR SAN FRANCISCO DIRECT.

THE SPLENDID A. No. 1 NEWLY COPPERED

PACKET SHIP APOLLO.

recently in the European trade, having most of her freight engaged, will sail for

SAN FRANCISCO, CALIFORNIA,

and the gold region in that vicinity, from the

Foot of Chambers Street, North River,

WHERE SHE NOW LIES, ON THE SECOND OF JANUARY NEXT.

Passengers will be taken on the following terms :

Steerage Passage - - - - - - $ 75.
Cabin Passage - - - - - - - 150.
Ditto out and home - - - - - 200·
Ditto with board while there 250.

Several Families can be Accommodated.

With the discovery of gold in 1848 along the Trinity River and the Sierra foothills, "gold fever" affected not only the eastern United States, but Europe too. Everyone flocked to California. The state's population grew from 15,000 in 1848 to over 200,000 in 1852. This large influx had a huge impact on the indigenous people of California. As Europeans and whites began staking homesteads, Native Americans became displaced. Their patterns of hunting and food gathering were interrupted. They began stealing food, even though it was against Native American culture. According to Benjamin Madley in his book *An American Genocide*, between 1846 and 1870, California's Native American population declined from an estimated 150,000 to 30,000. By 1880, that population dropped to 16,227. (Library of Congress.)

The 1850 Act for the Government and Protection of Indians denied Native Americans protection from slavery, vigilante justice, and other similar types of treatment. In addition to the US Army, troops paid by the governor of California fought to suppress Indian hostilities. The governor asked citizens to help fight. These groups were called "volunteers" or "rangers." Some people did object to the treatment of Native Americans; however, their voices were usually overpowered. (Library of Congress.)

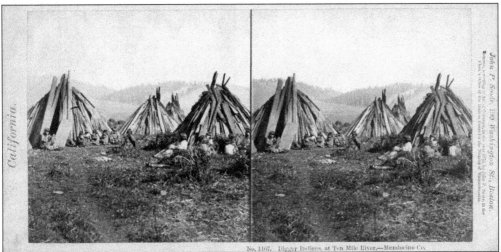

More and more Native Americans were herded to reservations. The conditions at the reservations were not adequate, and there was persistent starvation. At the Mendocino reservation (established in 1856), shown here, many Native Americans starved to death or suffered malnutrition. (New York Public Library.)

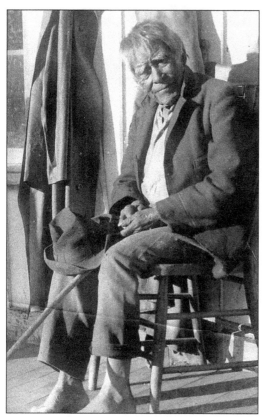

Col. Redick McKee, the US Indian commissioner, had tried to negotiate a series of treaties with 18 tribes. The Lost Coast area to be set aside for Native Americans would have included large tracts of land around the Eel River and Ferndale. However, in 1852, the US Senate voted to not ratify the treaties. This was known as the 18 Lost Treaties. Later, the new Indian commissioner, Edward Beale, proposed military-type reservations for Native Americans. Conflicts escalated between the Natives who did not relocate to the reservations and the new settlers. Many massacres occurred between 1850 and 1865. Some Native American women married white settlers, and other Native Americans began working for the ranches being developed. (Both, MVHS.)

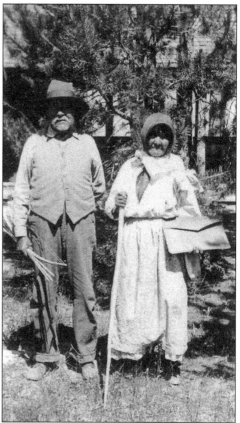

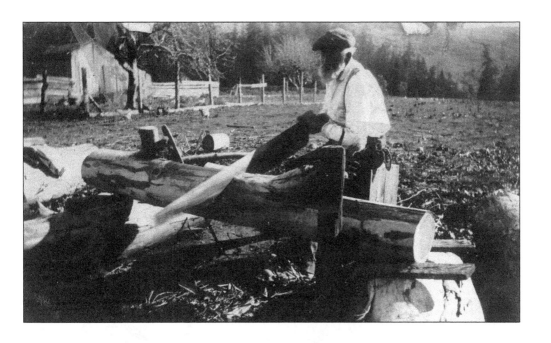

During this time period, many white settlers who traveled to Humboldt and Mendocino Counties to find gold ended up staying to farm and ranch. Homesteaders had to file claims through the Bureau of Land Management (BLM) using a preemptive claim. The cost was $1.25 an acre with a limit of 160 acres. Cattle were often raised. In the late 1800s, raising sheep became very popular as sheep were well suited for the land. With the influx of Europeans, dairies sprang up. By 1882, there were 81 dairies in Humboldt County, many in the Capetown and Bear River areas. (Above, MVHS; below, Humboldt State University.)

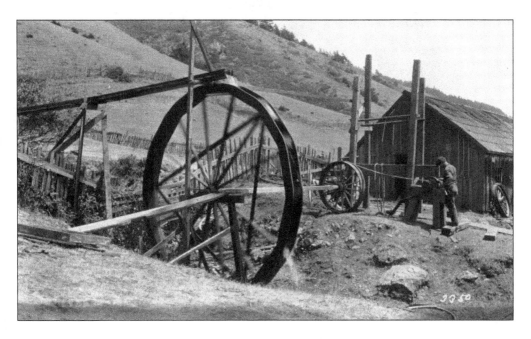

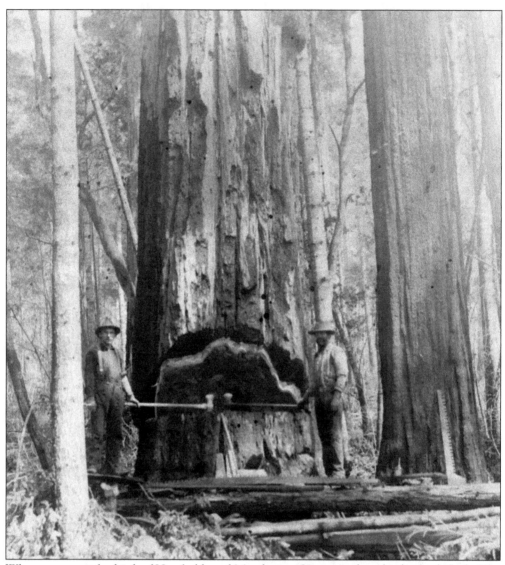

When many people think of Humboldt and Mendocino Counties, they think of redwoods. The coast redwood is the tallest species of tree in the world, reaching over 320 feet. Only about five percent of old-growth forests are still in existence from central California to southern Oregon. Redwoods thrive in areas with heavy rain and fog and in land less than 2,000 feet in elevation. On the northern part the Lost Coast, redwoods did not grow due to the higher elevation and harsh winds. Usually, coast redwoods grow within about 45 miles of the ocean, but in Humboldt County, the fog travels up the Eel River so coast redwoods are found farther inland than usual. Within northern Mendocino County, redwoods thrived. Some of the largest trees were found in the Usal forest (southern part of the Lost Coast). The photograph below was taken in 1912. (Above, author's collection; below, Library of Congress.)

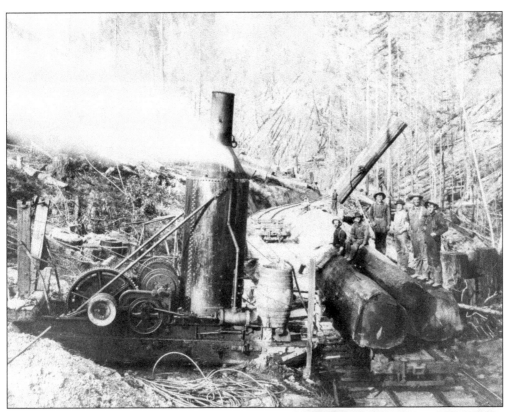

The first loggers concentrated on the trees easiest to log and transport out of the forest. They were ingenious in inventing varying ways to harvest trees. The steam donkey, a steam-powered winch, was invented by John Dolbeer of Eureka in 1881. The steam donkey skidded the log out of the forest. (Both, author's collection.)

An Avenue of Stately Redwood Trees, Humbolt Co. Cal.

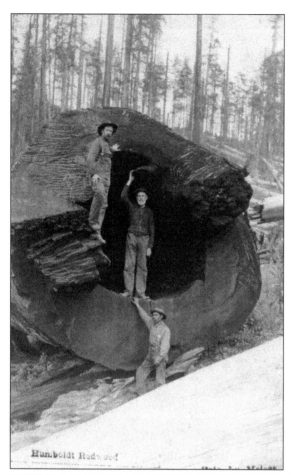

Humboldt Redwood

After the 1906 earthquake and fire, San Francisco had to rebuild. Redwood is fire-tolerant and resistant to decay, and old-growth redwood is prized for building. Redwood from Humboldt and Mendocino Counties was used throughout San Francisco. Massive amounts of timber were shipped to the Bay Area on schooners. Shown below, the schooner *Sea Foam*, built in 1873, made regular trips from Humboldt and Mendocino to San Francisco. It was lost at Point Arena in 1931. (Both, author's collection.)

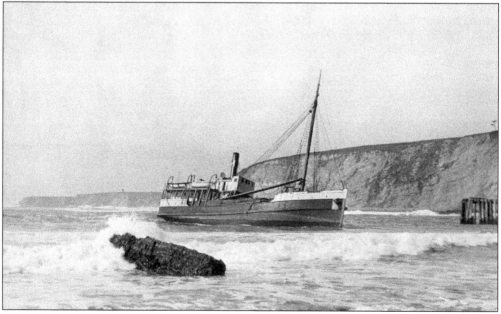

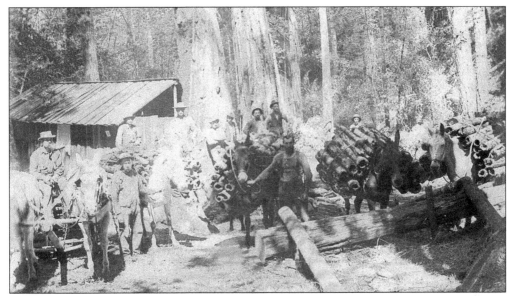

Tanbark was another industry of the North Coast. The bark of the tan oak tree was the most prized for curing leather. According to Frederica Bowcutt in her book *The Tanoak Tree*, leather manufacturing (due to the large amount of tan oak bark) was Humboldt County's third-largest industry from the late 1800s to the early 1900s. This photograph shows men bringing in the bark with mules around 1900. (Kelley House Museum.)

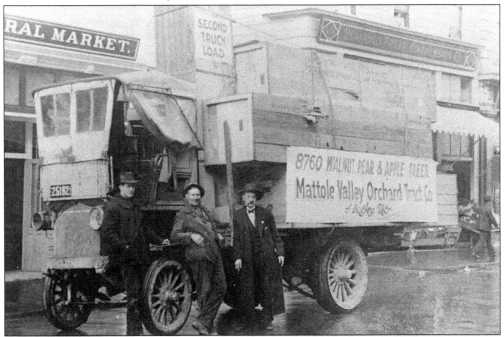

The fertile ground of the Mattole Valley, only miles from the coast, was ideal for many crops. Joseph Bagley, who grew extensive orchards in the valley, was the manager of the Mattole Orchard Company, seen here in the early 1900s. Many varieties of apples, as well as other fruit, were grown and shipped out. Until its demise in the 1910s, the Mattole Wharf shipped much of this produce. (MVHS.)

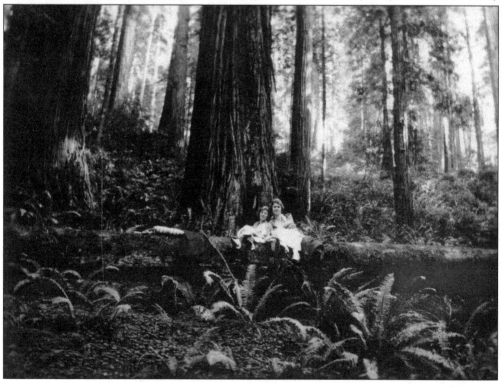

In early 1900s, Mendocino and Humboldt Counties were tourist destinations, especially for people from San Francisco. Seeing the redwood forest was a popular activity. This newspaper article from the *San Francisco Call* extols the virtues of the outdoors. Excursions were designed to behold the scenic wonders, and camps were developed. Camping was common at Shelter Cove. Fishing camps were also advertised, as well as areas for hunting. As the roads were developed, a popular activity was posing with trees. Leila Zimmerman is on the right in the photograph below, taken in 1919. (Both, author's collection.)

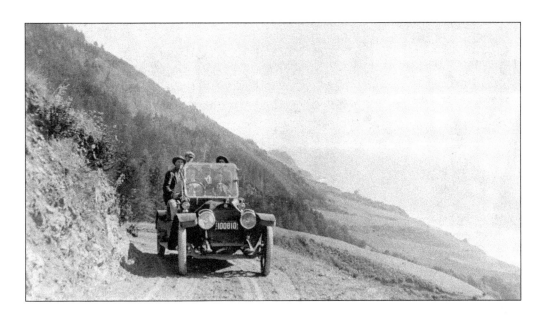

In 1895, the Bureau of Highways sent surveyors to each county. They prepared a map of the recommended system of roads and submitted it to the governor in 1896. In northern Mendocino County, engineers agreed with prior assessments and veered Highway 101 inland. In 1910, the Highway Bond Act was passed and construction of the Redwood Highway began. (Above, MVHS; below, Library of Congress.)

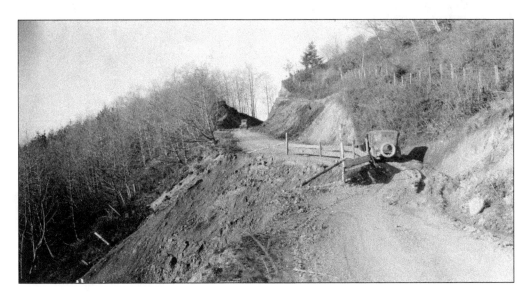

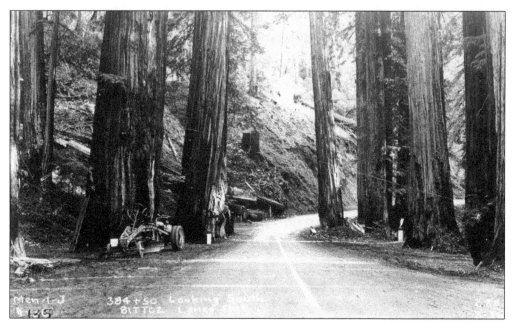

The difficult terrain has hindered the building of roads and has been, and continues to be, a major factor in the Lost Coast staying isolated. Building the highway was very difficult. Land surveyors and road builders had to pack in their own supplies. The first efforts were done with picks and shovels only. According to *A Glance Back* by Margarite Cook and Diane Hawk, in 1915 convicts were brought in to help. In 1918, the first steam shovel was used. These photographs show roadwork on the Redwood Highway from 1925 and 1930. Logs were used as guardrails. The highway was carved out of the redwoods but avoided the cliffs of the Lost Coast. (Both, Library of Congress.)

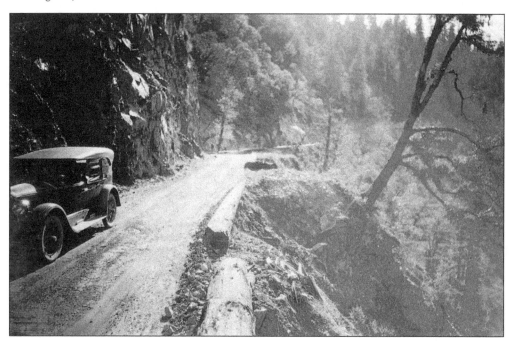

Two

NORTHERN LOST COAST

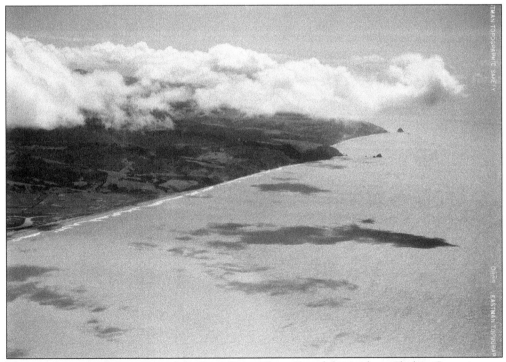

The northern coastal section of the Lost Coast, from Ferndale south to Shelter Cove, is now predominantly part of the King Range National Park. This aerial photograph shows the coastline from south of Ferndale to Cape Mendocino. False Cape and Cape Mendocino are shown as prominent landmarks jutting out from the coastline. The photograph is dated 1948. (Humboldt State University.)

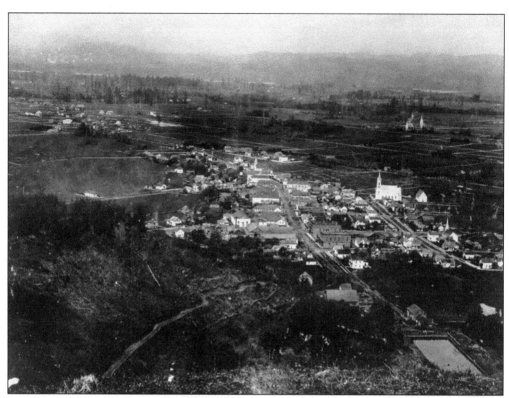

Ferndale is at the northern end of the Lost Coast. Known today as "the Victorian Village," it started out as a small homestead. In 1852, Seth and Stephen Shaw traveled up a tributary of the Eel River. They found a small creek at the base of the hills. There, they established two land claims and built a cabin. Eventually, Stephen sold his claim, and his brother Seth built a large house (now the Shaw House Bed and Breakfast). Seth named the town Fern Dale. The post office was established in 1860. According to the *History of Humboldt County*, the population was 350 in 1881. There were several stores, three churches, and a hotel. These two photographs show Ferndale in the 1800s. (Both, Greg Rumney.)

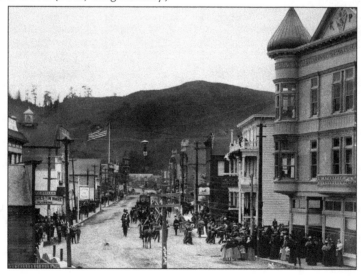

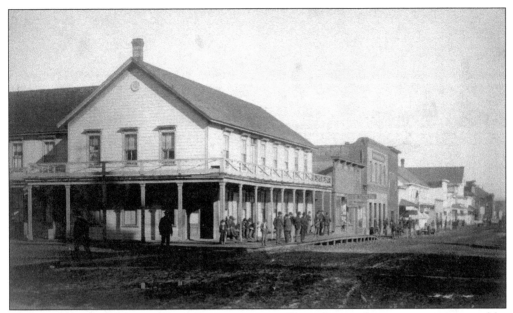

More settlers arrived from many different countries. Dairy farming became prominent, and by 1890, there were 11 separate creameries. Ferndale acquired the nickname "Cream City." This photograph shows downtown Ferndale. (MVHS.)

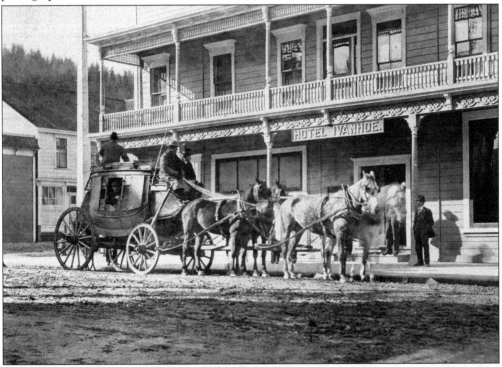

Ferndale was also known for being a hub for the stage lines that ran from the south (Bear River and Mattole Valley) up to Eureka. This was very important for the dairies and the crops that were raised in the Mattole Valley. The Ivanhoe, still in existence today, was a stopping point. (Greg Rumney.)

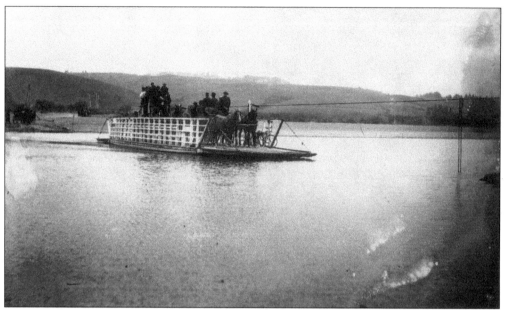

The Eel River meets the ocean near Ferndale. This river created a barrier between Ferndale, Bear River, Capetown, and the Mattole Valley and the towns on the other side, including those around Humboldt Bay. Two Wiyot villages were near this location. George Singley ran a ferry across the river starting about 1873 until the concrete bridge, called Fernbridge, was built in 1911. (MVHS.)

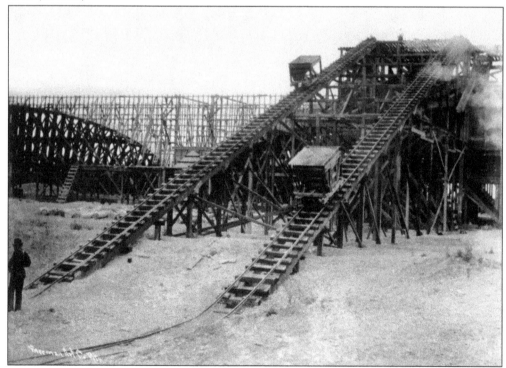

Jerry Rohde, in his book *Both Sides of the Bluff*, details how residents lobbied for a bridge starting in 1893. Work on the bridge did not begin until 1911. (Greg Rumney.)

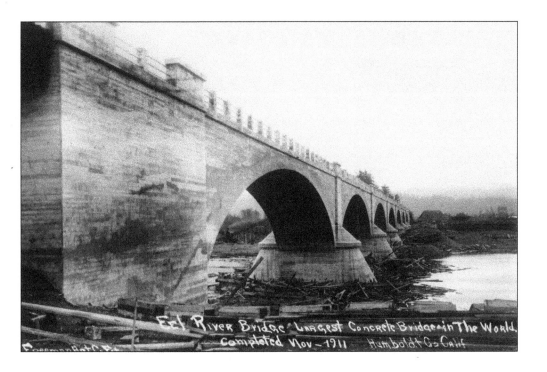

Eel River Bridge, Largest Concrete Bridge in The World. Completed Nov – 1911 Humboldt Co Calif

After much lobbying by citizens and two years of development, a 1,320-foot-long concrete arch bridge, designed by engineer John B. Leonard, opened in 1911 over the Eel River. This bridge, called the Queen of Bridges, was built at Greig's fishing resort near Singley's Station. Leonard used concrete as opposed to brick because of potential earthquakes. He designed this bridge based on his previous bridges built in San Joaquin County. (Above, Greg Rumney; below, Library of Congress.)

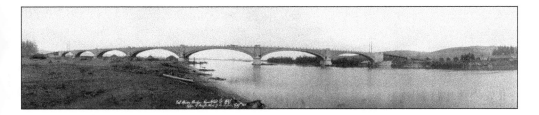

UNITED STATES MAIL LINE

FOR

PORTLAND,

Victoria, Port Townsend and Olympia.

The Mail Steamship

NORTHERNER,

W. L. DALL..COMMANDER,

Will leave Folsom street wharf

For the Above Port

on

TUESDAY,................JAN. 3, 1860,

At 4 o'clock P. M.

FORBES & BABCOCK, Agents.

For Freight or Passage, apply on board, or to the Agents of the Pacific Mail Steamship Company, corner Sacramento and Leidesdorff streets.
☞ Bills of lading will be furnished by the Purser to shippers of cargo. None others than those so furnished will be received. de30

The Wiyot village of Tokertayerwok was once near the head of Centerville Slough. This was the southernmost area on the coast where Wiyots lived. In the early 1850s, Centerville was a small settlement near the beach. In 1859, Arnold Berding operated a store and post office. There was also a hotel. On January 5, 1860, the *Northerner*, a paddle steamer, hit an underground rock near Blunt's Reef. Local residents gathered quickly to help the victims, but 38 people were lost and buried at a mass grave at Centerville Beach. A cross on the hill above the beach memorializes those lost. The photograph below is dated 1926. (Both, author's collection.)

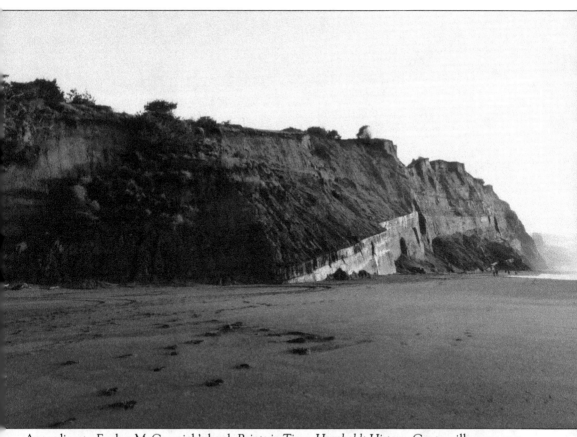

According to Evelyn McCormick's book *Points in Time, Humboldt History*, Centerville grew as a general supply depot for the area's settlers. It was also right on the route for traveling from Humboldt Bay. By the 1880s, though, Centerville was in decline. In 1949, Centerville Beach was turned into a county park. Currently, Centerville Beach is the northernmost point of the Lost Coast. Nine miles of beach with sandstone cliffs showcase a multitude of fossils. (Author's collection.)

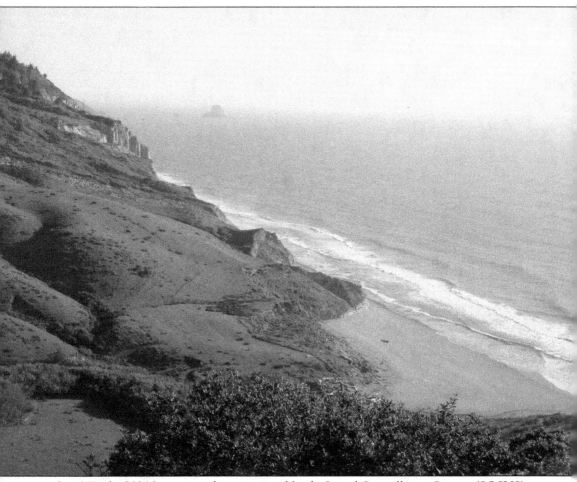

In 1958, the US Navy opened a secret worldwide Sound Surveillance System (SOSUS) near Centerville Beach to conduct underwater surveillance of Soviet submarines during the Cold War. At one time, over 300 personnel were stationed there. The facility was decommissioned in 1993, and the land was transferred to the Bureau of Land Management (BLM) in 2010. The Lost Coast headlands are now public lands comprised of 653 acres of former ranchland that overlook very steep cliffs, as well as Fleener Creek. These cliffs showcase sedimentary layers of ancient seafloors. A hiking trail leads to Fleener Beach. Agricultural grazing land surrounds the headlands. (Author's collection.)

Wildcat Road, originating out of Ferndale, began as a trail. Winding through dense Douglas fir forests then down steep hills, it leads to Capetown and Petrolia. During the 1880s, Chinese workers helped transform the trail into a road for stagecoaches. Guy Buell, in his 1916 publication *Pioneer Western Lumberman*, writes this about the Wildcat: "One needs the claws of such an animal in order to negotiate its vertical scenery." The Wildcat winds down to Capetown and Seven Mile Beach. (Both, MVHS.)

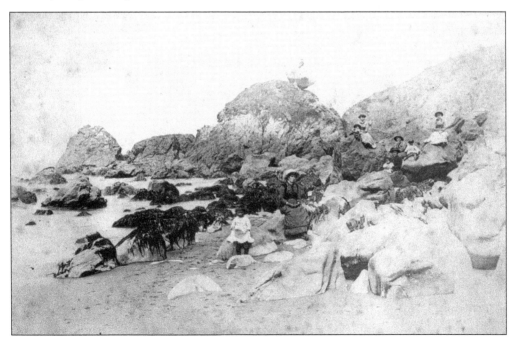

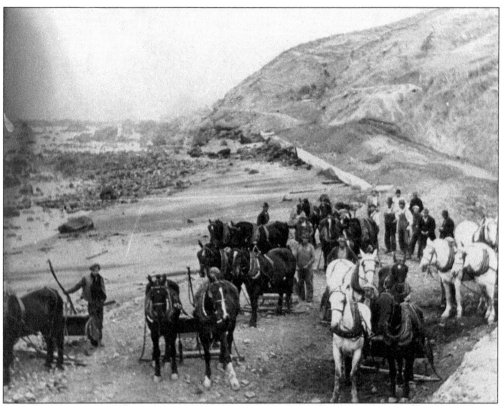

South of Ferndale, the mountains, called the Wildcat Range, are very unstable. They are also very steep. But a viable transportation method between Ferndale and the Bear River area and the Mattole was very important to residents and travelers. This photograph shows men working on the beach section of Wildcat Road. (MVHS.)

Since the mountains were difficult to pass, the regular road before construction of Wildcat Road ran right along the beach. The Beach Road was convenient but very treacherous. Wild waves toppled the Mattole stage in 1878. Wagons were often turned upside down. Eventually, a landslide completely blocked the beach road, and it was no longer passable. (MVHS.)

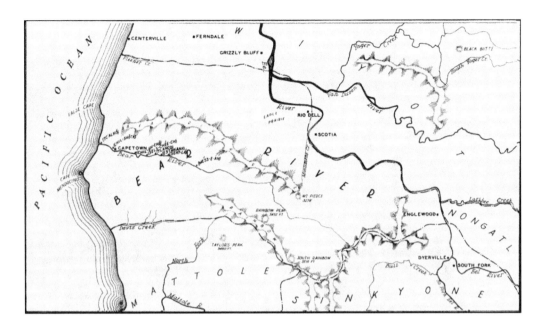

The Nek-an-ni lived along the Bear River and as far south as Davis Creek. The white settlers called them the Bear River Mattoles. They lived south of the Wiyots and near the mouth of the Eel River, bordered to the east by groups of Nongatls and to the south by the Mattoles. It is estimated that there were seven villages, and they had spiritual areas along the coastline. Today, not much is known about this group of Native Americans as they were almost completely obliterated when white settlers starting staking land claims. Anthropologists Pliny Earle Goddard and Gladys Nomland studied the Bear River Mattoles in the 1920s and 1930s. This map is from Nomland's article on interviews with some of the last remaining Bear River Mattoles. The photograph below shows Capetown, on the Bear River. (Above, Gladys Nomland; below, MVHS.)

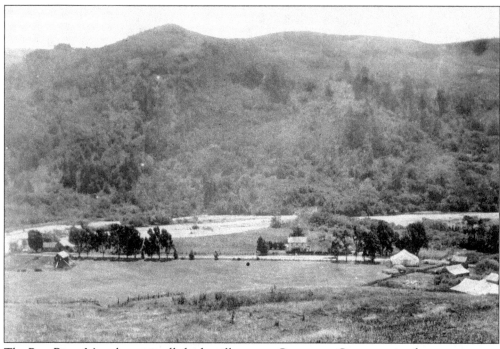

The Bear River Mattoles originally had a village near Capetown. Capetown is a former stage stop on the Bear River located 15 miles southwest of Ferndale on Wildcat Road, halfway between Ferndale and Petrolia. The first white residents were dairymen and farmers. Martin and Rachel Branstetter settled in the Bear River Valley in 1854. (MVHS.)

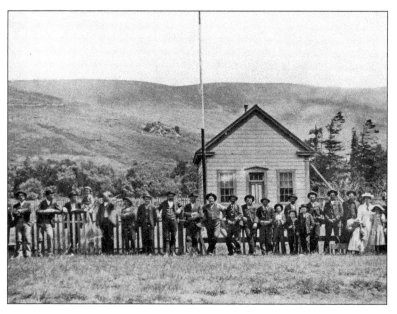

In the early 1900s, about 160 people lived in Capetown. Wildcat Road runs right through the town. Many of the area's children rode on horseback to school. The old schoolhouse has now been converted to a home. (Greg Rumney.)

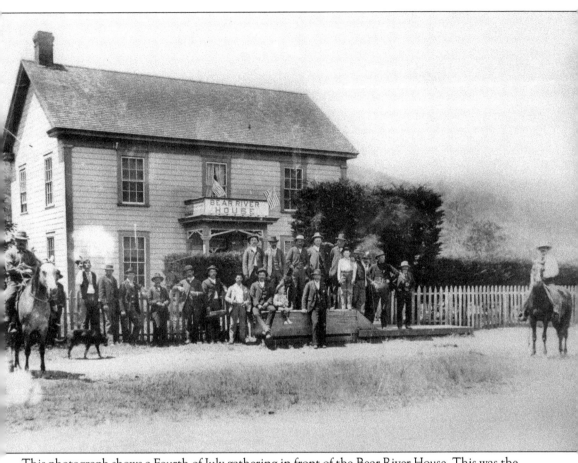

This photograph shows a Fourth of July gathering in front of the Bear River House. This was the first hotel in Capetown and accommodated the Petrolia stage passengers. On the Petrolia stage, it was a full-day ride from Capetown to Ferndale, so riders spent the night in Capetown at the hotel. Across the river from Capetown was a natural gas jet that, at one time, provided lights for the hotel. The former hotel is now the Branstetter home. (Greg Rumney.)

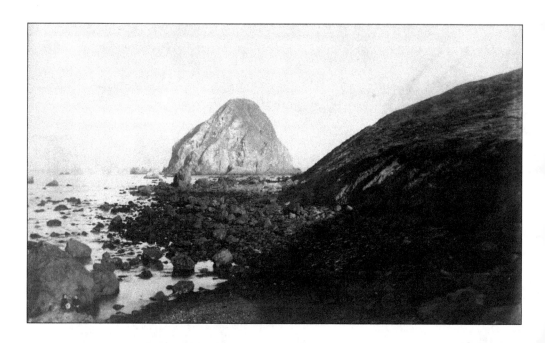

There is some debate on when Cape Mendocino was first sighted by Europeans and named. It was officially named in 1543 after the viceroy of Spain, but the explorers may have actually been somewhere else. It was placed on maps in the early 1600s but sometimes in various locations. Nevertheless, this was an area that early explorers grew to be fearful of. Harsh weather, rough seas, reefs, and scurvy plagued the explorers. There is no protection from the weather at Cape Mendocino. (Both, Humboldt State University.)

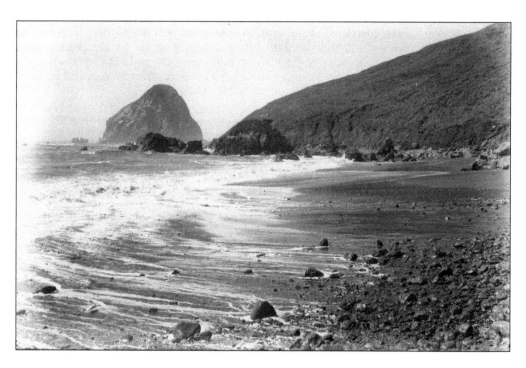

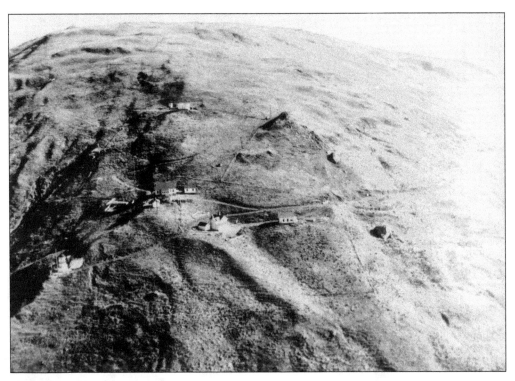

Cape Mendocino, surrounded by rocks and often covered with fog and battered by strong winds, is considered one of the most dangerous spots in the Pacific Ocean due partly to sunken rocks. According to Pliny Goddard, there were a number of Native American villages near the Bear River and Cape Mendocino. These Native Americans spoke a different dialect than the Mattoles. The above photograph gives an aerial view of the lighthouse area with its outbuildings. The photograph below shows Sugarloaf Rock off the cape. (Above, MVHS; below, author's collection.)

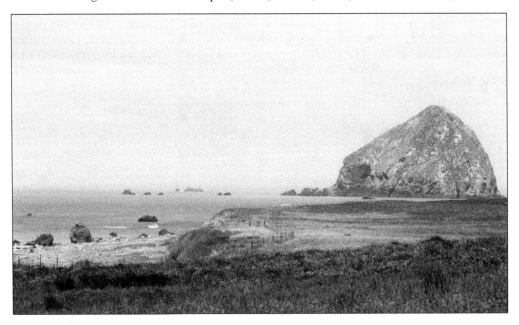

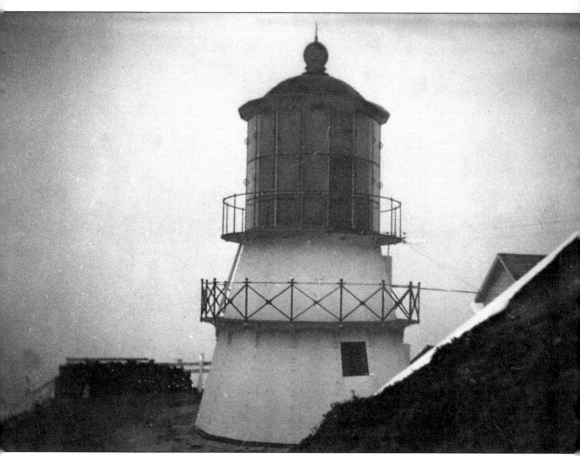

The Cape Mendocino Light was built in 1868 to help prevent additions to the numerous shipwrecks in the area. Because of the steep terrain, a flat area 422 feet above sea level was carved out of the hill. A 43-foot tower was built and bolted to a concrete pad. The lighthouse had 16 sides and two balconies. Alfred May was the first lightkeeper. Living conditions were very rough for the keepers and their families. The lighthouse property had 172 acres, and one keeper raised ponies for the stage line. In 1939, the Coast Guard took over. The lighthouse was automated in 1951. (Greg Rumney.)

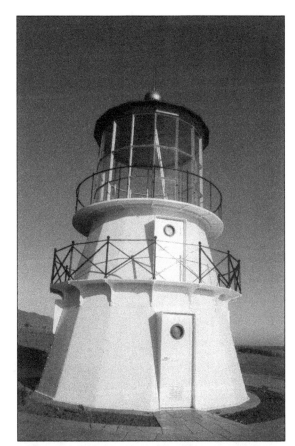

After being automated, the lighthouse building began to deteriorate in the harsh weather. The lighthouse's tower was moved to Ferndale in 1948, and the outbuildings were burned. In 1998, volunteers from the Cape Mendocino Lighthouse Preservation Society moved the lighthouse to Mal Coombs Park in Shelter Cove where it resides today. A historical marker designates a spot on the coastline to commemorate the lighthouse. (Both, author's collection.)

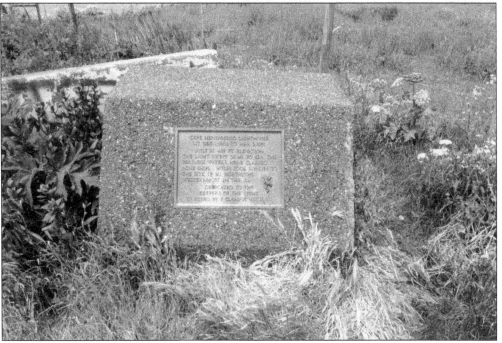

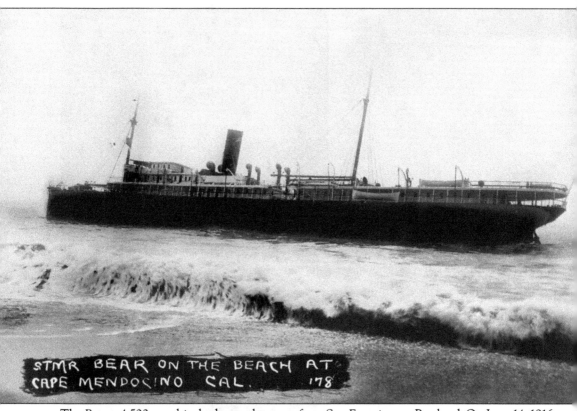

STMR BEAR ON THE BEACH AT CAPE MENDOCINO CAL. 178

The *Bear*, a 4,500-ton ship, had a regular route from San Francisco to Portland. On June 14, 1916, the ship was headed south with 182 passengers and crew. In the thick fog, Capt. Louis Nopander thought he was about three miles offshore. When he altered his course for Point Arena, he was closer to the shore than he thought and ended up stranded on a reef, 100 yards off Cape Mendocino. Twenty-nine passengers were immediately put into a lifeboat but capsized in the rough seas. Five drowned. Locals took the survivors to Capetown. (Greg Rumney.)

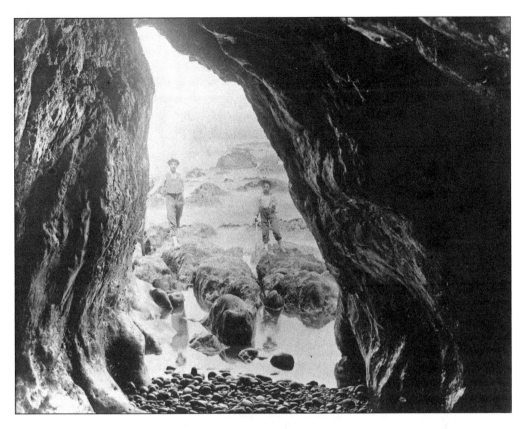

The coastline near Cape Mendocino is a nine-square-mile marine-protected area known as South Cape Mendocino State Marine Reserve. Cape Mendocino is one of the most recognizable spots on the Lost Coast. The photograph above shows one of the many sea caves. The image below offers a view from the south. (Above, Kelley House Museum; below, author's collection.)

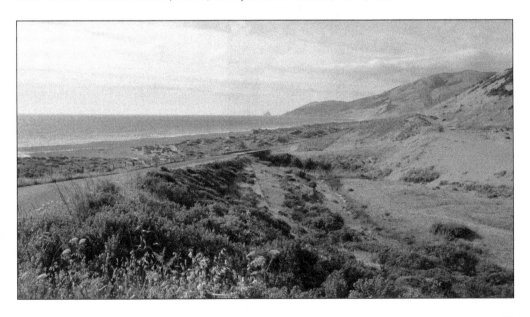

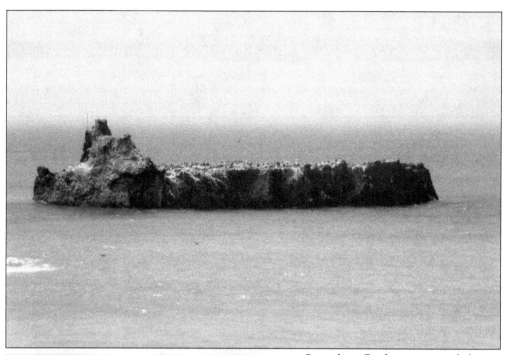

Steamboat Rock is positioned about 200 feet offshore. Over the years, it has been mistaken for a steamer with a low black hull. There are many Native American legends associated with Steamboat Rock. It supports an annual breeding colony of cormorants and is now a Northern California Marine Protected Area. (Author's collection.)

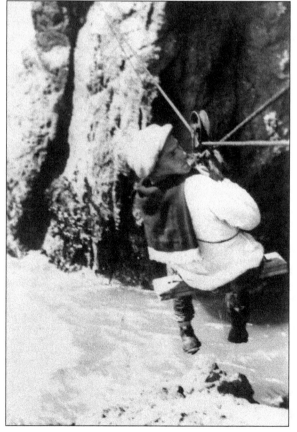

Off the edge of Cape Mendocino lies Sugarloaf Island. It is now part of South Cape Mendocino State Marine Preserve and closed to public access. This is an important breeding area for seabirds. This photograph shows Rae Wright on a primitive zip line to Sugarloaf in the 1930s. (MVHS.)

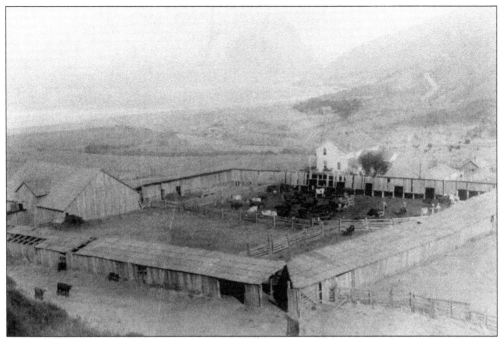

Joseph Russ came to Humboldt County in 1852 from Maine. Russ and his wife, Zipporah, accumulated thousands of acres of land. He raised cattle, rented land for dairies, and owned stores and other businesses. He was also involved in the timber business. The Ocean House Ranch, where Russ raised sheep, still exists and is located near Seven Mile Beach, just south of Cape Mendocino. (MVHS.)

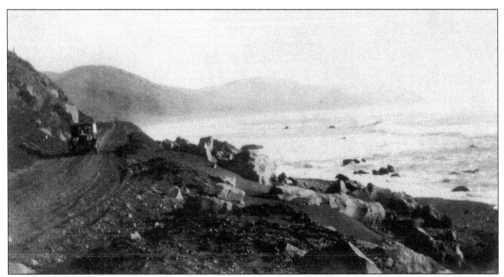

This photograph shows Devil's Gate, which is about two miles south of Cape Mendocino on Mattole Road. Three miles off the reef of Cape Mendocino is Blunts Reef. It is a collection of rocks and sea pinnacles that are dangerously hidden. A lightship station was established for protection from 1903 to 1971. (MVHS.)

At the southern base of Cape Mendocino, going southward on Mattole Road, is Seven Mile Beach. This early photograph shows two fishermen, from left to right, unidentified and Rae Wright. Rockfish are plentiful in the area. This area is now popular with kayakers. (MVHS.)

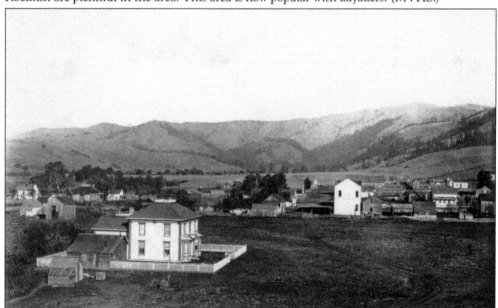

A few miles inland from the ocean is the pastoral small town of Petrolia. It was the site of the first oil well drilled in California. As early as 1857, ranchers reported finding oil. In 1864, the first store in what was called Lower Mattole was a log building with planks across two barrels. In 1865, the first shipment of oil left the newly named Petrolia for San Francisco. This early photograph of Petrolia was taken in 1888. (MVHS.)

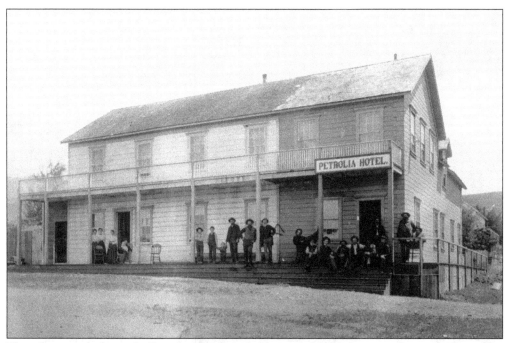

This photograph shows the Petrolia Hotel, probably around 1900. It was in the southwest corner of the square. Charles Doe was the first manager of the hotel in 1869. In 1903, a fire swept Petrolia and the hotel burned. (MVHS.)

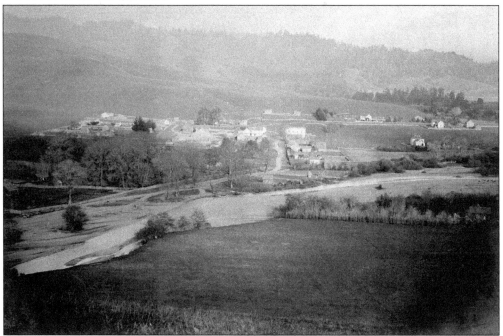

The 1881 *History of Humboldt County* describes Petrolia: "Its location is a quiet place with mild climate, while the pepperwood, alder, cottonwood, madrone and buckeye form a pleasing background . . . it commands the trade of both Upper and Lower Mattole Valleys." This photograph was taken before the April 1903 downtown Petrolia fire. (MVHS.)

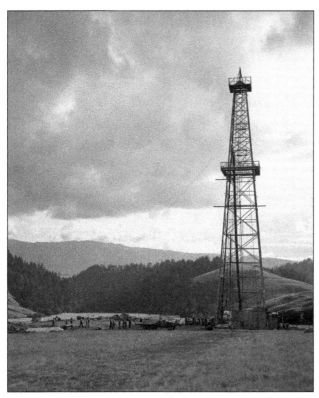

The early Mattole settlers discovered oil in springs. They used it in their coal oil lamps. At first, residents expected their discovery to be a true bonanza; however, it did not work out that way. The oil was not in the huge quantities that were expected, and by 1866, it had dried up. Nevertheless, settlement continued in Petrolia. (Both, Greg Rumney.)

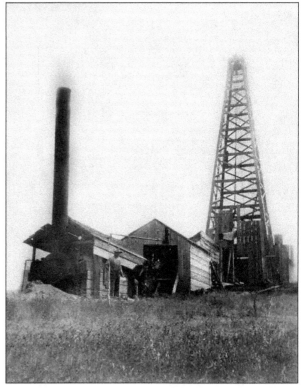

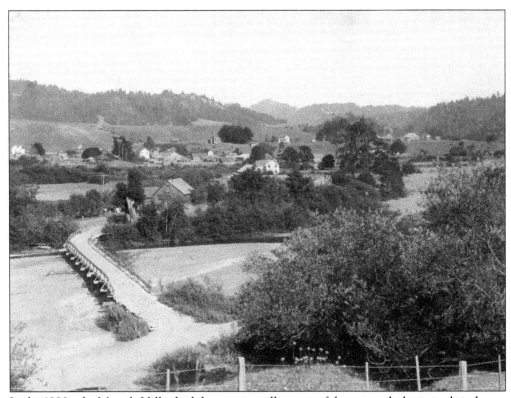

North Fork Mattole Petroleum Mining Co

Assessment No. 2

Levied, *Jan 25th* 1866 *Eureka, Humboldt Co. Jan 27* 1866 $ 90 00

Received of *W. C. Martin* the sum

of *Ninety* Dollars, being

an Assessment of *One Dollar* per Share on *Ninety*

Shares of the Capital Stock of the above Company, standing in the name of

W. C. Martin on its books.

No. Certif. *17 to 21* *Geo. A. Watson* Secretary.

Towne & Bacon, Printers

After oil was discovered in Petrolia, other areas throughout the county developed mining districts. This is a copy of a certificate from the North Fork Mattole Petroleum Mining Company from 1866. The company did fairly well and sent oil regularly to San Francisco. (MVHS.)

In the 1880s, the Mattole Valley had three grain mills, successful crops, and a large cattle industry. There were several businesses in the town of Petrolia. There was also a post office as well as a school in the Upper Mattole Valley. About 1900, telephone service was introduced. (MVHS.)

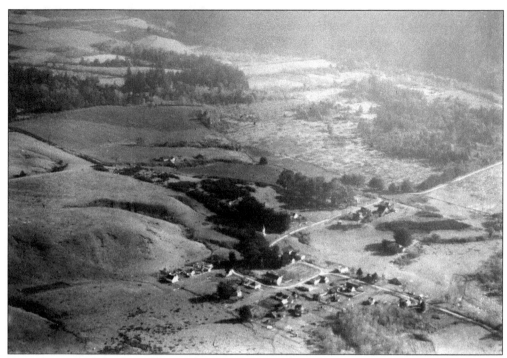

From the time of the first white settlement, the Mattole Valley was recognized for its fruits and vegetables. This area, with its hot summers and wet winters, was perfect for growing. Benjamin Etter moved to Humboldt County in 1896. His son Albert Etter started growing strawberries and experimented with plant breeding on his land near Bear Creek. He became known as the "Luther Burbank of Humboldt County." Albert also experimented with apples. He published several journals on plant breeding and was known for growing plants from seeds. Nearby Ettersburg was named for the Etter family. The photograph below, dated 1969, shows the Ettersburg General Store. (Both, MVHS.)

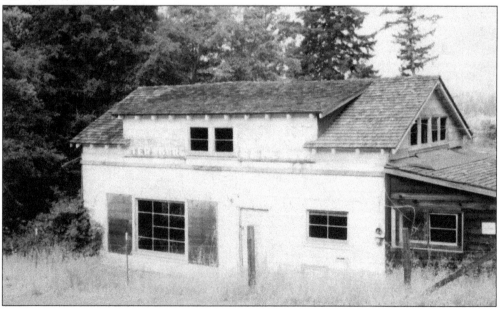

The Mattole Valley Grange was formally chartered in 1934. The Grange building is the site of many community events. This photograph is from the Harvest Festival in 1936. Note the line of cars. (MVHS.)

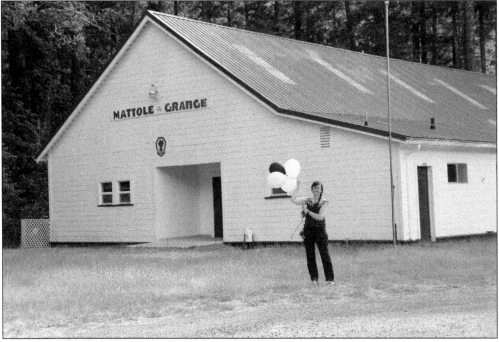

The Mattole Valley Grange is still a very active organization. It is also home to the Mattole Valley Historical Society, headed by Laura Cooskey. She is the area's historian and author of the blog *West of the Redwoods*. (Author's collection.)

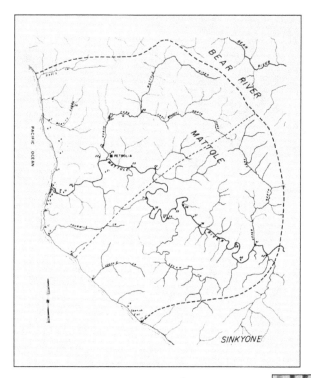

The Mattoles called themselves the Bet-tol or the Pet-tol. Not many records exist on the Mattoles, mainly because of their elimination during the Indian Wars. A.L. Kroeber, who wrote the *Handbook of the Indians of California*, said that in 1910 there were only 10 native Mattoles still living. The area of the Mattoles extended from Davis Creek in the north (just south of Devil's Gate) to Spanish Flat in the south. This map, from Gladys Ayer Nomland's *Bear River Ethnography*, was published in 1938. (Author's collection.)

Major Boy Clark was said to have been found as an abandoned infant. The belief is that his parents were killed by white settlers. He was adopted by Charles and Martha Clark in 1862, and they raised him with their family. He worked for his neighbors, had a house in Petrolia, and is believed to have lived well into the 20th century. (MVHS.)

Joe Duncan was born before 1850. He and his son Isaac were interviewed by anthropologists in the 1920s and 1930s. Reportedly, Joe could speak his native language, which was very rare by that point. He and his son lived by the mouth of the Mattole River and worked as ranch hands. The Mattoles were particularly targeted for removal as the white settlers saw the value of the land the Mattoles were living on. (Both, MVHS.)

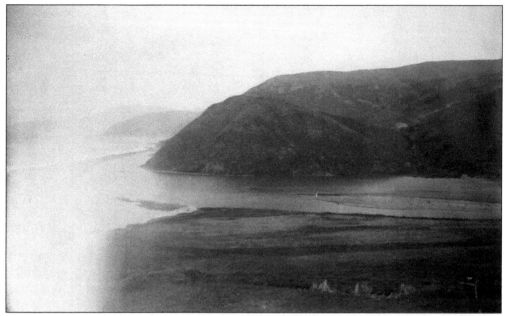

Between the coast and the Mattole River, European settlers staked many claims and started ranching. Raising sheep was dominant from 1867 to 1880 but declined due to the decrease in wool prices along with foreign competition. Raising cattle became more popular. The land in this area was perfect for grazing. The beaches between Shelter Cove and Petrolia were sheep-gathering spots. A few cabins, called "line shacks," were built. In 1862, John Barkdull and his family were among the first to own land in this area. His daughter, named Mendocino, was reportedly the first white girl born in Humboldt County south of Cape Mendocino. They had a dairy on their 160-acre homestead. (Both, MVHS.)

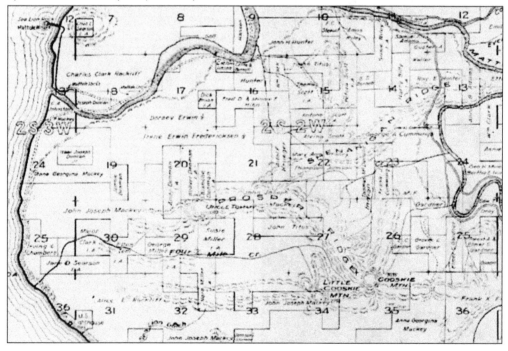

These photographs show Johnny Jack, another Native American survivor, in 1949. He lived on a barge at the mouth of the Mattole River. In the Mattole language, the river was called Tatyi. Johnny's mother died in 1880, and his father died in 1906 at age 75. Another Native American survivor was Squire Morrison, who died in 1928 at the age of 70. He was said to have been rescued from the Squaw Creek massacre, and eventually was adopted by the Morrison family and lived near the Bear River. (Both, MVHS.)

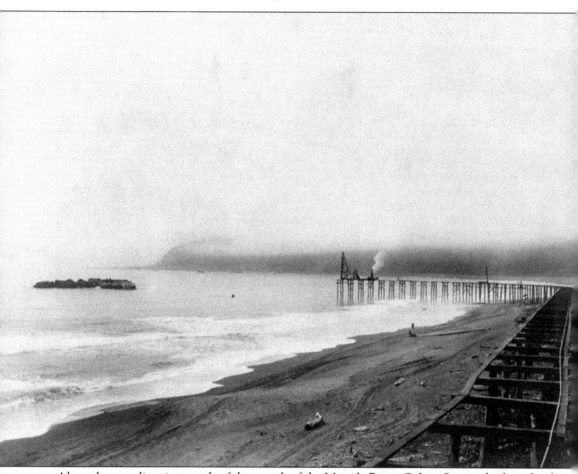

Along the coastline, just north of the mouth of the Mattole River, Calvin Stewart built a wharf out to Sea Lion Rock for a shipping point. Stewart lived in Petrolia and worked in tanbark and lumber. This photograph shows the wharf construction in progress but not yet complete; it was dedicated and nearly ready for business in August 1908. A steam donkey is being used as a pile driver. Sea Lion Rock is at far left. (Greg Rumney.)

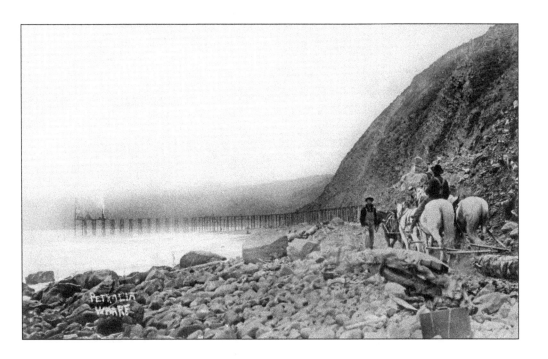

These photographs show the wharf completed, which occurred in late 1908. A narrow-gauge railroad was also constructed for 2.5 miles along the north bank of the Mattole River out to the rock. This became the main shipping point for the Mattole Valley. Lumber, tanbark, apples, and wool were among the items loaded onto ships. (Both, Greg Rumney.)

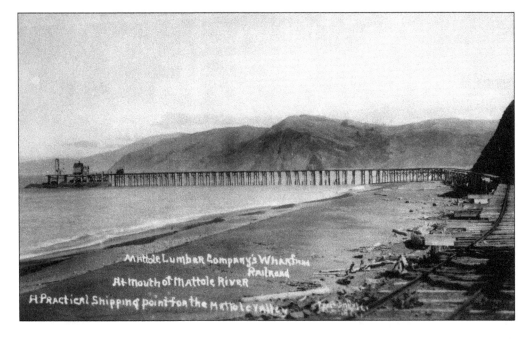

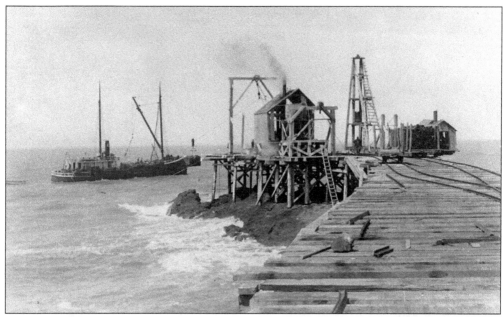

The *Cleone* was a 119-foot steamer built in San Francisco in 1887. It is shown here being loaded by wire chute at Mattole Landing. Later, the vessel ran ashore at Punta Gorda and was a total loss. (Kelley House Museum.)

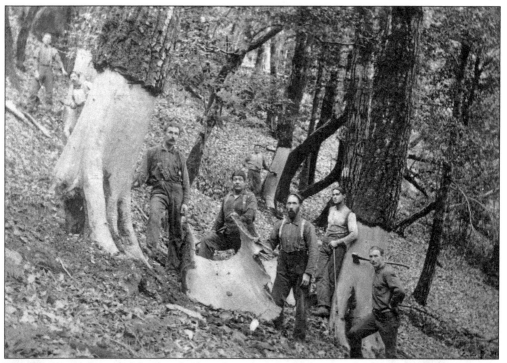

Tan oak trees were peeled for their bark as they contained tannic acid, which was used in tanning leather. The trees were peeled with a chisel-like tool called a spud. Workers focused on the trunks of the trees where the bark was thick. Most of the time, the tree was left to decompose. (MVHS.)

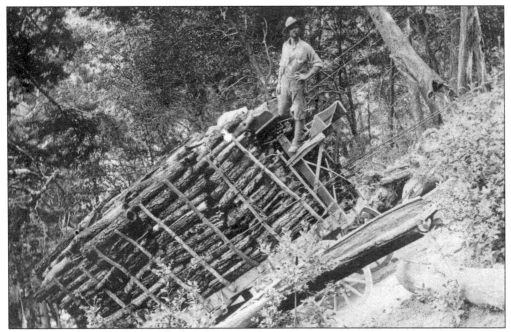

The bark was piled into wagons and hauled out of the forest. Often, a steam donkey was used to pull the wagons up steep inclines. The bark was taken to San Francisco or Stockton for processing. At that time, San Francisco had more than 50 tanneries. (MVHS.)

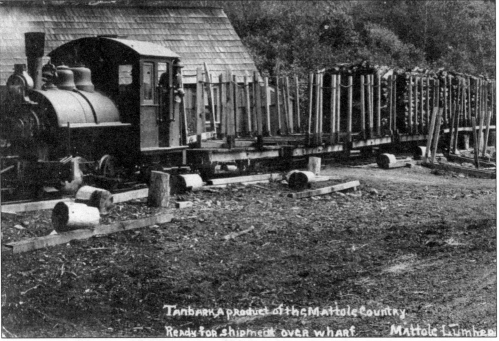

The train hauled the products being shipped down to the wharf. This photograph is from 1910. After the landing was destroyed and the engine abandoned, Henry Sorensen restored the old steam engine. It is now on display at the California Railroad Museum in Sacramento. (MVHS.)

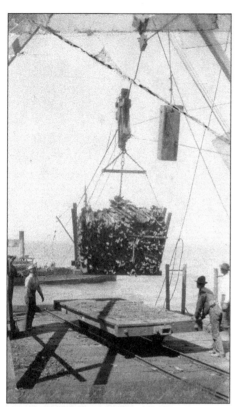

Using a cable, the bark was then loaded to the waiting ships. Tanbark, until the supply was depleted, was a major product. According to the book *The Tanoak Tree* by Frederica Bowcutt, in 1882 tanners paid $14 to $18 per cord. (MVHS.)

The Mattole Landing was very low, so it was tough on the ship's rigging. (A higher landing has more direct pull on the offshore anchor and therefore less strain on the ship's boom.) This made it unpopular with some ship captains. Nevertheless, the landing operated until the late 1910s when it was destroyed by storms. (Greg Rumney.)

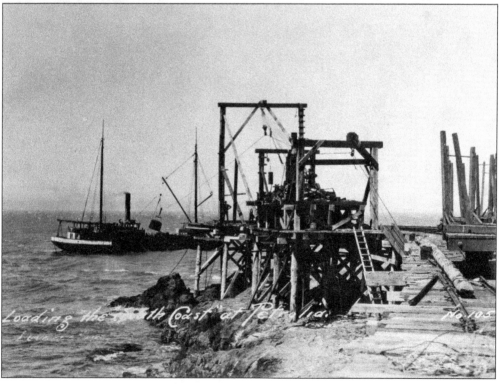

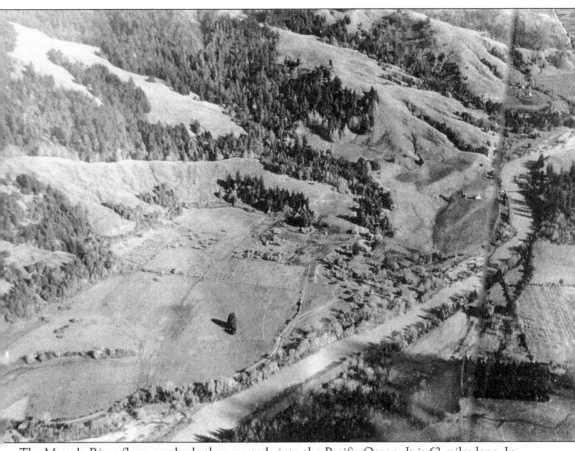

The Mattole River flows northerly then westerly into the Pacific Ocean. It is 62 miles long. In recent years, residents have been concerned about the rivers. The Mattole Restoration Council was formed in 1983. It is a community-based restoration group dedicated to restoring the Mattole River watershed. This aerial photograph shows an area around the Upper Mattole River and valley. (MVHS.)

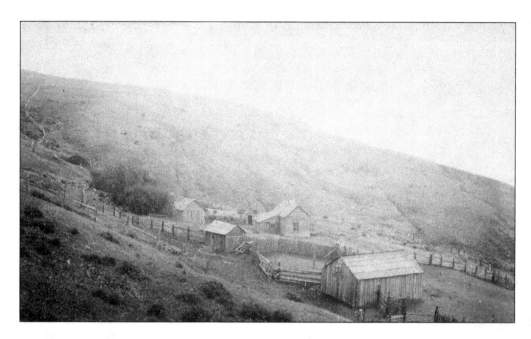

John and Patrick Mackey settled near the Cooskie Range around 1860. They accumulated thousands of acres in the next few years and operated a successful cattle ranch. John and Florence Mackey had a store and a home in Petrolia. They also maintained a coast ranch, seen pictured above. Mackey raised cattle at the ranch. This is a few miles south of the trailhead for the Lost Coast Trail. The trail then winds down the coast from here to Shelter Cove. (Both, MVHS.)

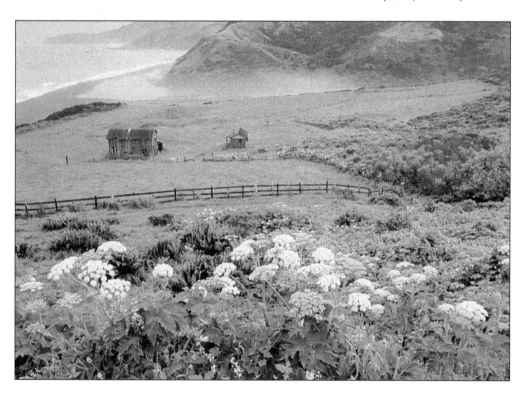

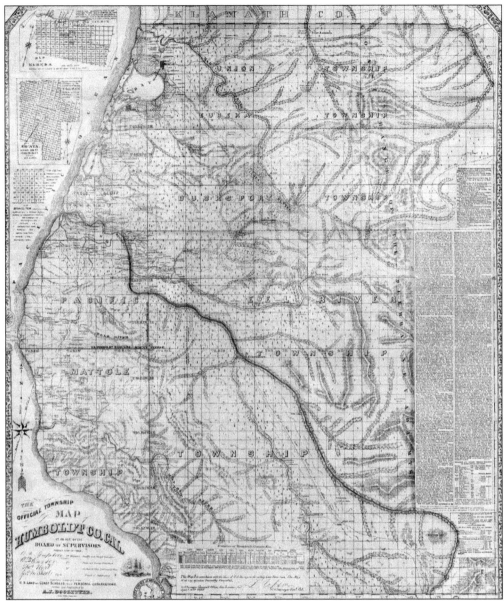

This 1865 map of Humboldt County illustrates the county by township. The Humboldt portion of the Lost Coast is all contained in the Pacific and Mattole townships. The map is useful in that it describes the land areas, such as "chapparell mountains" for the King Range. Parcels for early land owners are identified. In addition, "gas jets" are indicated on the map near Petrolia, as well as the oil lands. The Salt River, once a navigable channel of the Eel River, is also shown. In later years, the effects of logging and agriculture closed up the channel. In recent years, a restoration process of the Salt River has been in effect. (David Rumsey maps.)

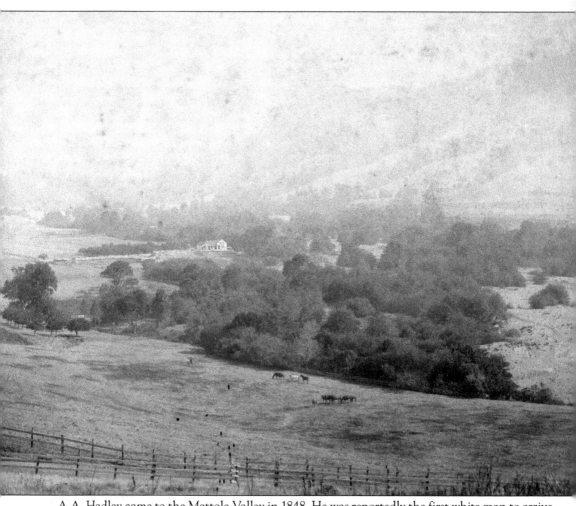

A.A. Hadley came to the Mattole Valley in 1848. He was reportedly the first white man to arrive in the valley. He later returned the next year to stay and settled on the river at Upper Mattole. Hadley married Annie Ruche Singley, and they had 11 children. Annie was said to be the daughter of a Russian trapper and a local Indian woman, and was raised by the Singley family. The Hadleys also had a ranch on the coast near Spanish Creek. By 1865, others soon came to settle, including the Conklin, Clark, Cook, Chambers, Rackliff, Walker, and Wright families. They all have descendants in the area. This photograph was taken from the Clark Cemetery. (MVHS.)

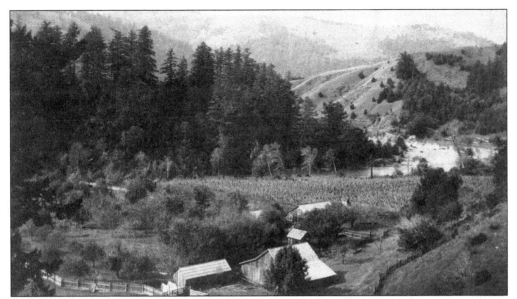

This c. 1900 photograph shows the Miner ranch in the Middle Mattole area. The Miners were the first of the Marysville settlers in the late 1860s. In the 1860 census for Mattole Township of Humboldt County, most occupations are listed as farmers and stock raisers. (MVHS.)

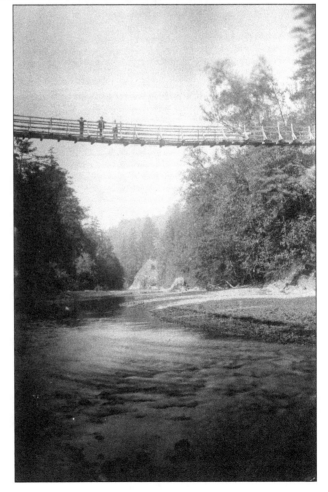

Members of the Roscoe family were also early settlers. This photograph shows the cable bridge over the Mattole River near their property. (MVHS.)

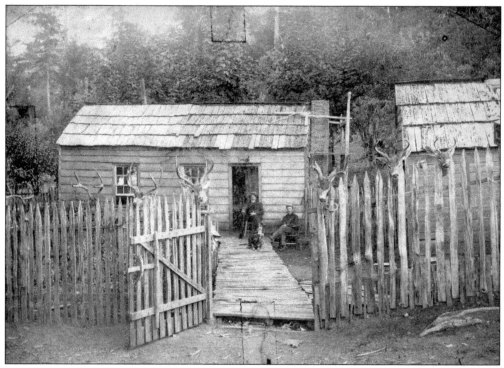

Before the bulk of mountain and coast land became the King Range Conservation Area, the mountains were used for hunting—first by Native Americans and later by white settlers. Hunting cabins were built and hiked to for seasonal hunting. The cabins shown here enjoyed by members of the Roberts family were in the Cooskie Ridge area. (Both, MVHS.)

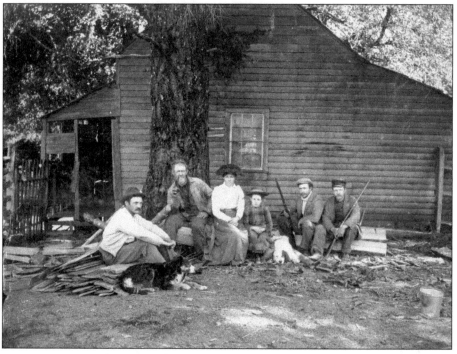

Cooskie Mountain is at 2,950 feet in elevation. Trails were developed through the mountains, oftentimes using existing Native American and/or animal trials. The land around the mountain is perfect grazing land, which attracted many of the first white settlers. The grassland and fir forests have large populations of deer and bear. (Both, MVHS.)

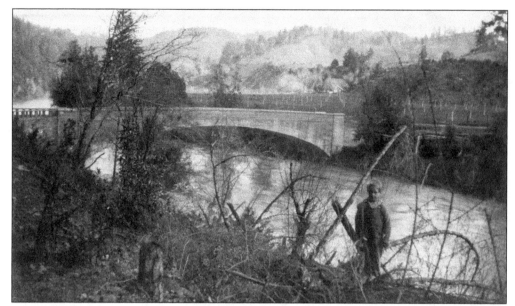

There are many tributaries that feed into the Mattole River as it wanders through Humboldt County on its way to the Pacific Ocean by way of Whitethorn, Ettersburg, Honeydew, and Petrolia. This photograph of Ruby Senn was taken in 1923. (MVHS.)

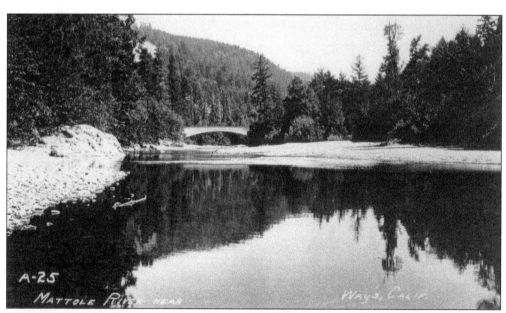

A-25

MATTOLE RIVER NEAR Ways, Calif.

This concrete arch bridge was constructed around 1920. This photograph was taken on the Mattole River below Squaw Creek, at A.W. Way County Park. Before the bridge, the road ran along the west bank of the Mattole River at the base of Cooskie Mountain. (Library of Congress.)

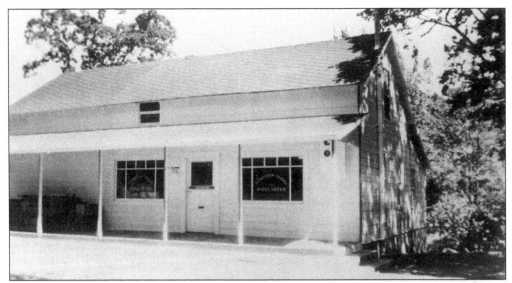

The Honeydew Store has been the mainstay of Honeydew for many decades. It is still open today and a gathering point for residents in the area. Honeydew is on the Mattole River, about equidistant from Highway 101 and the ocean. Honeydew was one of the original stagecoach stops. The first post office opened in 1926. (MVHS.)

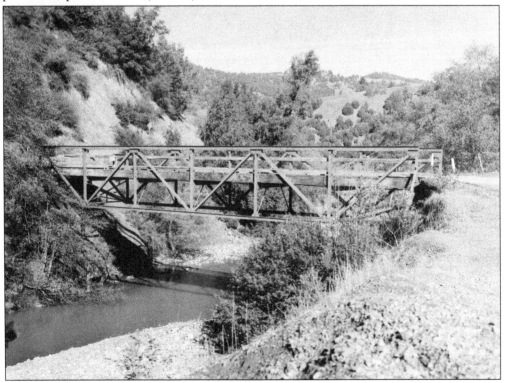

Built in 1925 on Wilder Ridge Road near Honeydew, this was the only inverted truss bridge in California. It was demolished in 1980. Based on its unique design and architecture, it was eligible for inclusion in the National Register of Historic Places. Honeydew averages well over 100 inches of rain per year. (Library of Congress.)

An early description of the Mattole Valley and Honeydew from a June 1855 article in the *Humboldt Times* describes the valley: "There are two valleys south of this, each described as but little short of a paradise . . . they describe the Mattole Valley as containing prairie land sufficient to supply one hundred farms of one hundred and sixty acres each. At the head of the valley three streams unite and form the Mattole River . . . surrounding the prairie land is to be found table lands, gently sloping backwards . . . the valley is completely locked in by hills, which shut off the cold fogs of the ocean." (MVHS.)

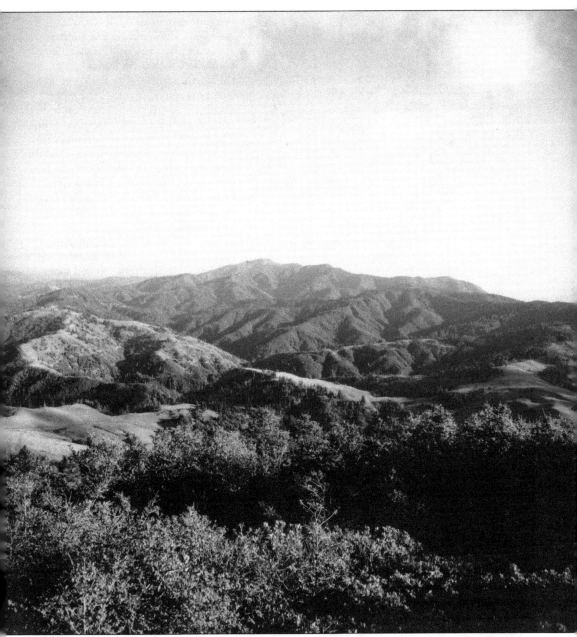

King Range National Conservation Area (KRNCA) is comprised of 68,000 acres. King's Peak is the highest mountain in the range at 4,087 feet and is only three miles from the ocean. KRNCA has 24 miles of the Lost Coast Trail, mostly along the beach. The conservation area stretches north from the Sinkyone Wilderness State Park to the Mattole River and extends to approximately six miles inland. Before the park was created, the area was all privately owned for ranching. The largest landowners in the park area were the Mackeys. Congress declared the land as a national conservation area in 1970. (MVHS.)

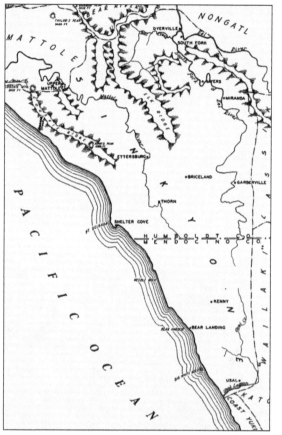

According to anthropologist Gladys Nomland, the Sinkyones, a southern Athabascan group, held territory from Fourmile Creek (near Punta Gorda in the north) south to the Rockport area. The Sinkyones are one of the more documented groups of American Indians and are known for their facial tattooing. There is debate about the origin of the name *Sinkyone*. Some historians feel the term was coined by ethnographers; but some researchers believe it is derived from "sinkene," which Sinkyones called themselves. In winter, the Sinkyones had permanent villages along the streams and in valleys. In summer, they lived on open mountainsides and hilltops. The Sinkyones shared some traits with northern groups, such as the Yuroks and the Hupas, and also shared characteristics with their neighbors to the south—namely the Yukis and Pomos. The Sinkyones were bordered to the south by the Coast Yukis and by the Mattoles to the north. However, Indians who lived in villages near borders usually spoke the languages of both groups, and some identified with more than one group. (Both, author's collection.)

Early white and European settlers used the land in this area in a variety of ways. The inland meadows were perfect for crops and farm animals. The coast held perfect grazing areas for cattle, and ranchers grazed cattle up and down the coast as early as 1850. Ranchers took the cattle from the mouth of the Mattole River to Shelter Cove and sometimes over trails all the way to Usal. The ranchers camped out all along the way. The drives north from the Mattole Valley to Ferndale took three days. The above photograph shows thrashing at the Mackey place on Chambers Road. The photograph below shows cattle being driven along the coast. (Above, MVHS; below, Greg Rumney.)

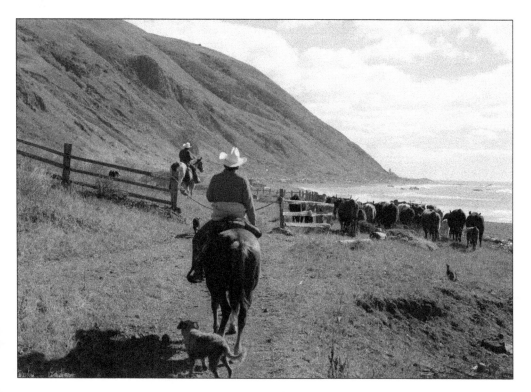

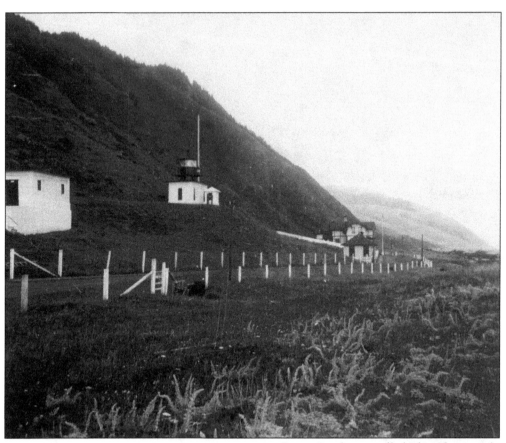

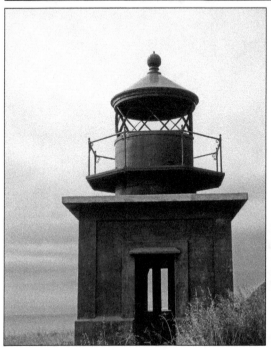

Punta Gorda was called "the Alcatraz of Lighthouses" due to its inaccessibility. It was built in 1911 and had its first light installed in 1912. Situated on 22 acres, it was 12 miles south of Cape Mendocino. There were two rough ways to get to Punta Gorda—over a long trail through the hills or on a shorter route on the beach by the Mattole River. The second route was much harder in the winter. Supplies were brought in by horseback, mule-drawn wagons, and sleds that were pulled along the beach. The sea was too rough to transport items, although that route was tried occasionally. Paschal Hunter was the first lightkeeper. He transferred from Cape Mendocino. Unfortunately, he died of a heart attack in the first year of his service. (Above, MVHS; left, Greg Rumney.)

Within the compound, the small two-story lighthouse was located south of three buildings that the keepers lived in. They also built, over time, storage sheds, the oil house, a blacksmith shop, and a barn for the horses. At only 22 feet, the lighthouse was not tall. The keepers' houses were built similarly to the ones constructed at Point Cabrillo Lighthouse in Mendocino, California. Old Bill was one of the last horses at Punta Gorda, having been there for 30 years. (Both, Greg Rumney.)

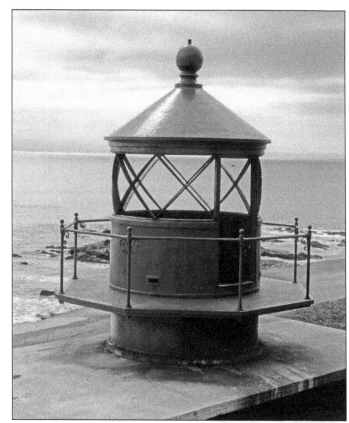

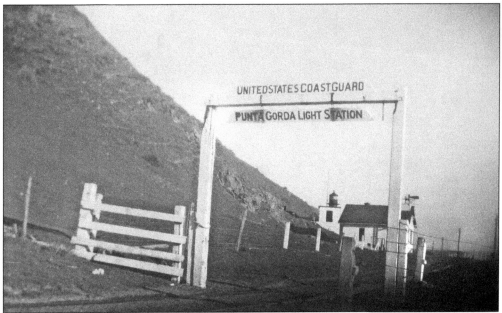

During World War II, the Coast Guard moved in and built a road along the foot of the bluffs. Guardsmen used the area for beach patrols. Winter storms sometimes blocked the road, so the horse Old Bill continued to be important for transportation. (Both, Greg Rumney.)

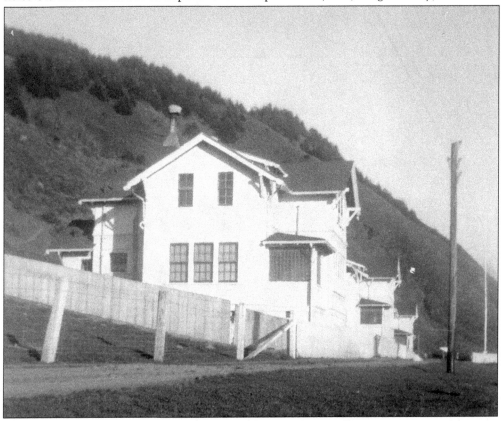

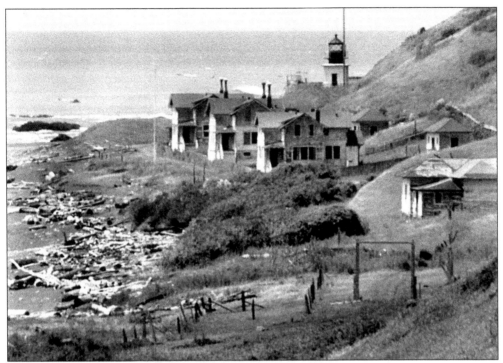

All supplies had to transported in by various methods, sometimes along the beach. In 1951, Punta Gorda was shut down. It was too expensive to maintain the lighthouse, and it was not needed any longer. Old Bill was moved to a pasture in Ferndale. The houses were essentially abandoned to the elements, and the land was turned over to the Bureau of Land Management (BLM). Hikers would explore the buildings in the picturesque setting. However, the BLM judged this as a nuisance and burned the buildings in 1970. Today, only the tower and the oil building exist. (Both, Greg Rumney.)

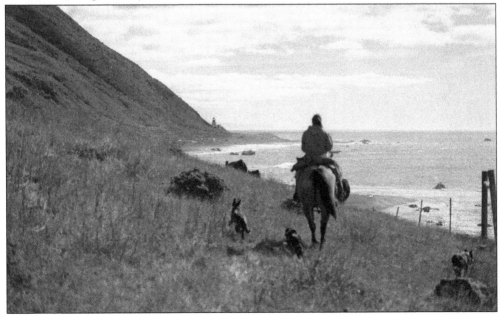

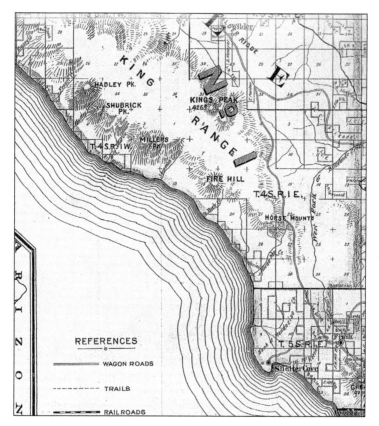

This map from 1898, published by Lentell, shows the coastline south to Shelter Cove. Seen is the wagon road from Shelter Cove north through Wilder Ridge and other peaks, which were often named after landowners. (MVHS.)

This is a photograph of the ranch at Big Flat where Don and Keith Etter worked from 1928 to 1933. (MVHS.)

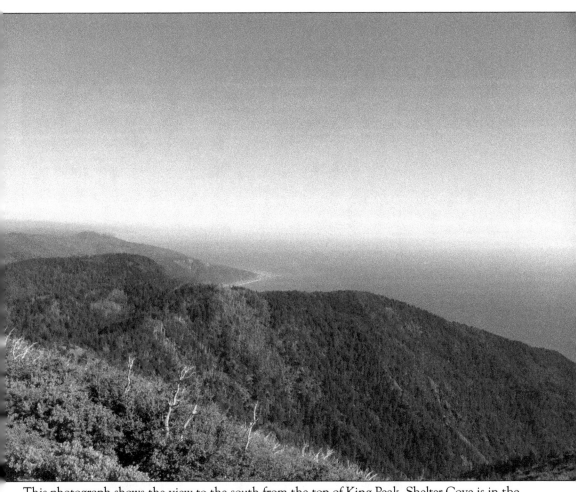

This photograph shows the view to the south from the top of King Peak. Shelter Cove is in the distance. J.J. McCloskey writes about Shelter Cove in a 1915 issue of *Pacific Motor Boat*: "On clear days one can look the Mendocino coast down from here and see Pt. Arena, 65 miles away." (Author's collection.)

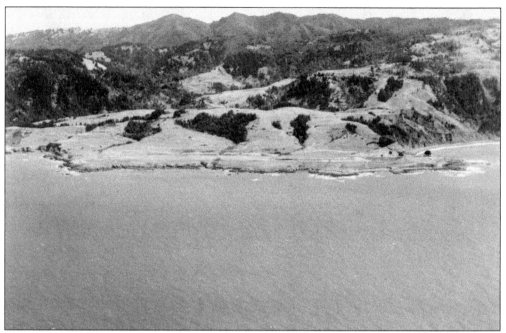

According to anthropologist Samuel Barrett, the Sinkyone village at Shelter Cove was called Tangating. Pictured are Athabascans from Briceland in a photograph taken by ethnographer Pliny Goddard in 1903. Jennie Woodman, third from the left, provided many interviews to anthropologists. (Above, Greg Rumney; below, Phoebe A. Hearst Museum of Anthropology.)

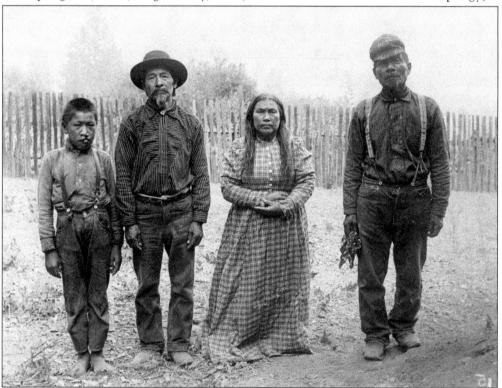

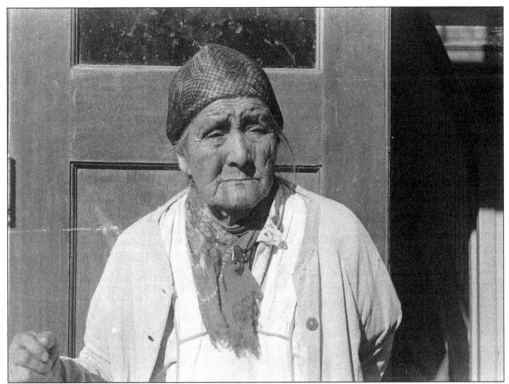

This is a photograph taken of Jennie Woodman in the summer of 1948 by Mary Jean Kennedy as part of the California Ethnographers Field Photographs. The Sinkyones had many villages in the Shelter Cove area. (Phoebe A. Hearst Museum of Anthropology.)

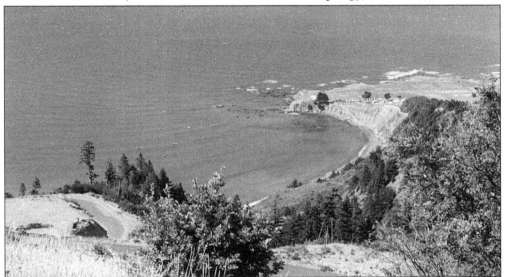

In the 1881 *History of Humboldt County*, Shelter Cove is described: "The harbor is a perfect shelter from the heavy north winds, but storms from the south have full play . . . The exports from Shelter Cove for 1881 were: 220,000 pounds of wool, 8 bundles deer skins, 2 bundles pelts, 13 cases merchandise, 2 boxes eggs, 1 bundle furs, 1G bundles leather, 1 box seeds, 1kegs butter, 13 sacks dried fruit." (Greg Rumney.)

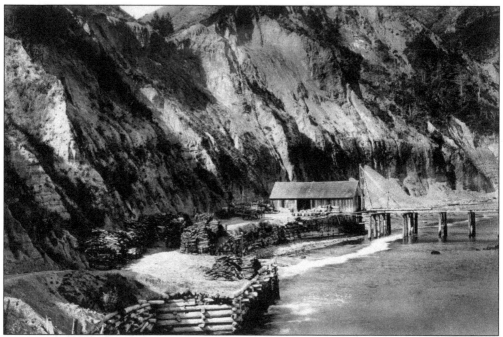

In the early 1850s, the Ray brothers claimed squatters rights to what is now Shelter Cove. They quickly developed a shipping agreement with passing vessels to get them to stop at Shelter Cove. The Robarts brothers built a warehouse. In 1885, they built a 960-foot wharf to load ships. It was a difficult process to build the wharf due to storms. (Greg Rumney.)

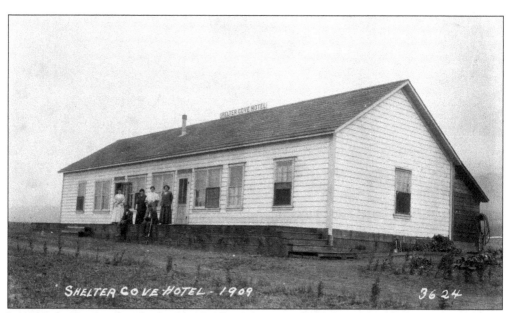

In 1886, the Ray brothers built a hotel. After John Ray's death in 1898, the wharf was owned by several people. By 1908, the Bowden brothers bought a half interest. This 1909 photograph shows Margaret Gildea Bowden and William Bowden at far right. (Humboldt State University.)

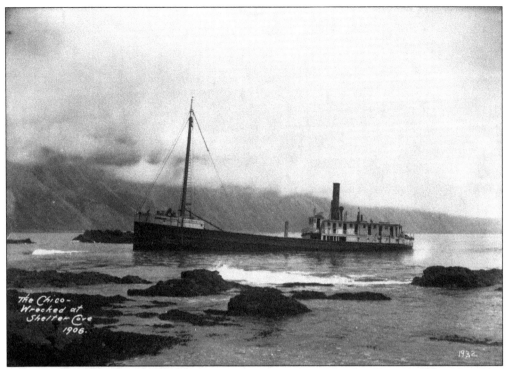

At this time, the wharf was 860 feet long. On July 18, 1906, the cargo ship *Chico* found itself in heavy fog and was grounded on the rocks. Although the harbor is a shelter from the heavy north wind, it does not have protection from the south. (Humboldt State University.)

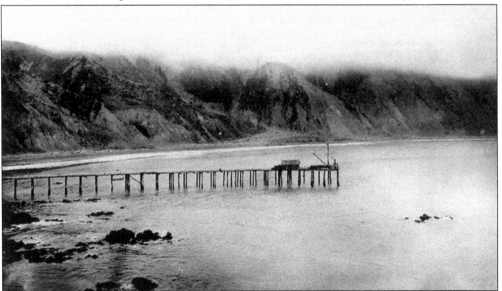

After the tan oak industry slowed, fishing became the main industry. From 1925 to 1931, the San Francisco International Fish Company leased the wharf. However, in 1931, it decided the wharf was too expensive to maintain and stopped the upkeep. The pier became unsafe to use, and Shelter Cove became a deserted area. However, during World War II, the US Coast Guard leased the property for beach patrols. (Greg Rumney.)

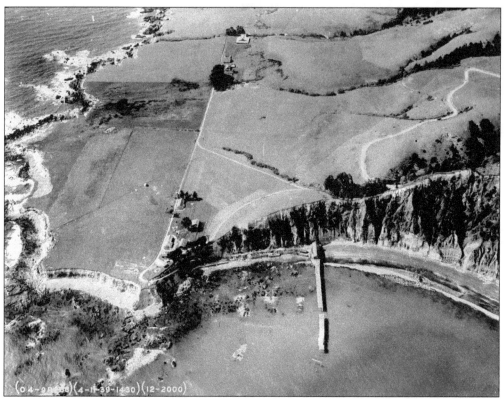

This aerial photograph, dated 1939, shows Shelter Cove before it was developed as it is today. (Greg Rumney.)

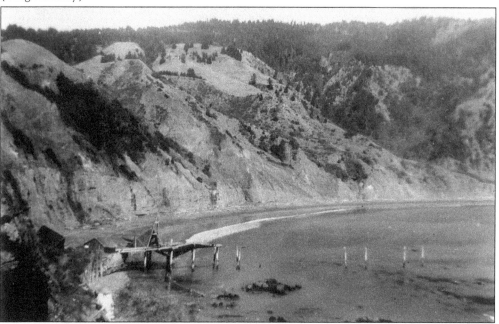

The pier went through various stages of decay until most of it fell into the sea. This photograph is dated 1940. (Greg Rumney.)

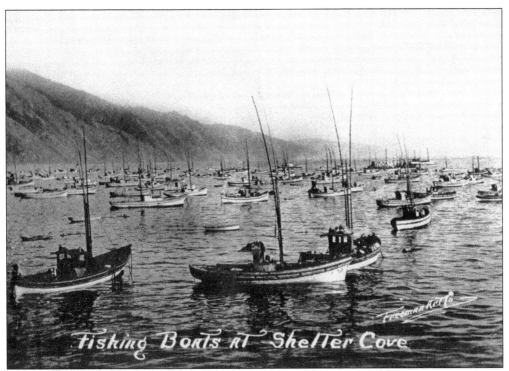

The Machi brothers—Mario, Babe, and Tony—spent their summers working in Shelter Cove when they were young. Being familiar with the area, they arrived in Shelter Cove with a dream. They were able to purchase the Shelter Cove property and decided to offer a boat rental business since the pier had eroded. They also developed a restaurant. By 1947, they had remodeled the old hotel. Roads were still an obstacle in getting to Shelter Cove. (Both, Greg Rumney.)

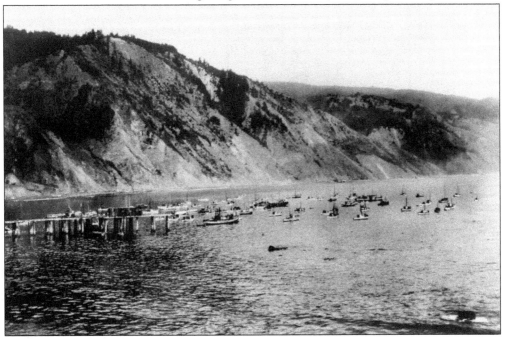

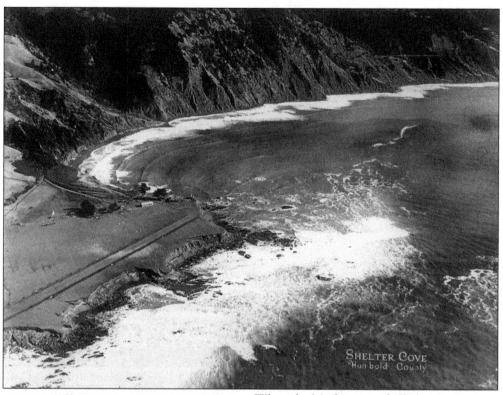

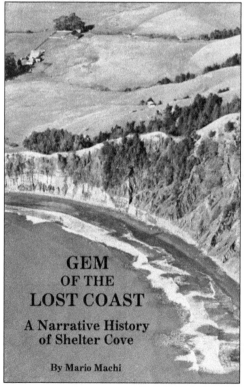

When the Machis arrived, Shelter Cove had essentially been abandoned. After they developed the restaurant, the Machis remodeled the old Coast Guard barracks into a home. In 1984, Mario Machi wrote his story in the book *Gem of the Lost Coast, A Narrative History of Shelter Cove*. It chronicles the history of the Shelter Cove, as well as his life. (Above, Greg Rumney; left, author's collection.)

In the early 1960s, the Shelter Cove Ranch was sold to a land development company. Initial plans were for 4,500 homes to be built. The biggest obstacle for the development was the road to Shelter Cove. From Highway 101, the first 15 miles were paved, but the remaining 15 miles were little more than a dirt trail. The airstrip was expanded so that potential home buyers could be flown in. However, in 1972, with the passage of Proposition 20, the Coastal Commission placed limits on development. This essentially stalled the large development. (Both, author's collection.)

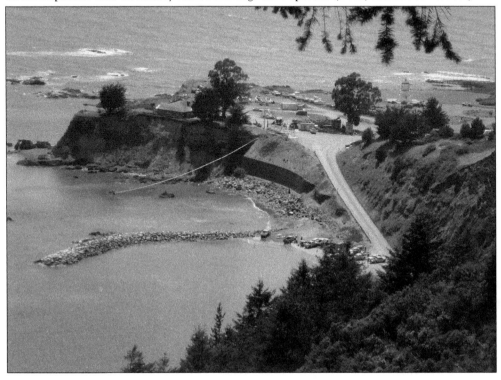

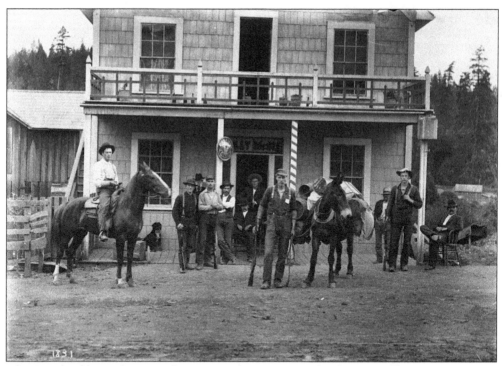

John Briceland began living in the area now known as Briceland in 1889. The town grew when the Wagner Leather Company built a tan oak extracting plant. The town had a school, two stores, a post office, and several other businesses. By 1922, when the supply of tan oak was depleted, the plant closed, and the town never regained the population it once had. The above photograph from 1907 shows Billy McGee's saloon. The town suffered a massive fire in 1914, and this saloon was one of the few businesses that survived. Below is the tanbark storage shed. (Above, Humboldt State University; below, Kelley House Museum.)

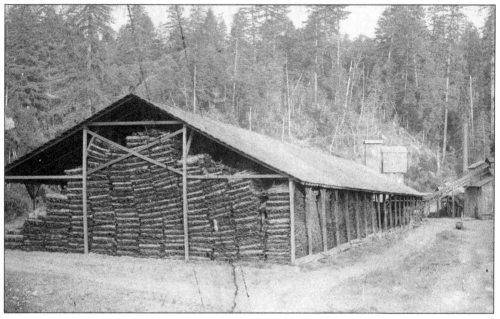

Three

SOUTHERN LOST COAST

The Mendocino County line along the coastline marks the area where the Sinkyone Wilderness State Park begins. The Sinkyone Wilderness State Park comprises 13 miles of the Mendocino County coastline just south of the Humboldt County line. For thousands of years, Native Americans lived in this area. Sinkyone villages were primarily located inland so that they were protected from the harsh winter storms along the coastline. During the summer, Native Americans moved out to the coast. (Library of Congress.)

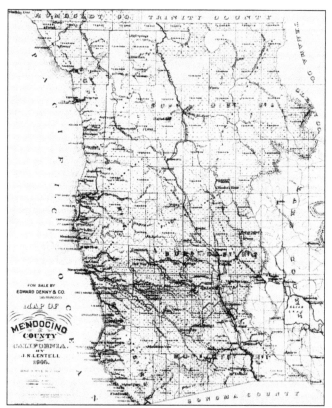

In the 1970s, the State of California began accumulating land north of Bear Harbor for development into a wilderness area. In 1986, a total of 3,000 acres was added to the south. About 70 percent of the park is a forest that has Douglas fir and coast redwood. The remaining portions are grassland, scrub, and chaparral with some limited areas of wetlands. The 7,500 acres are managed as a wilderness. This land has very steep rugged slopes with cliffs as high as 800 feet. At the bases of the cliffs are rocky beaches. Unlike in the King Range, the redwoods line the coastline. There are three old-growth redwood areas in the park: the Chase Grove, School Marm Grove, and the Sally Bell Grove. (Both, author's collection.)

Four Corners, at the intersection of Briceland-Whitethorn Road and Usal Road, is believed to have been a Native American meeting place thousands of years ago. This 164-acre property was given to the InterTribal Sinkyone Wilderness Council in 2012 by Save the Redwoods League. Sally Bell, who survived the Needle Rock Massacre in the 1800s, lived here until the 1950s. The land was slated for logging, but the council intervened to save it. Sally and her husband, Tom Bell, are buried at Four Corners. (Author's collection.)

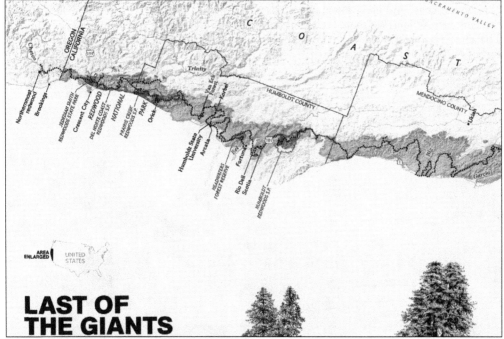

LAST OF THE GIANTS

This map, produced by Save the Redwoods, illustrates the growth path along the coastline. In the King Range National Conservation Area, the redwoods grow inland. At about the Mendocino County line, the redwoods grow to the coastline due to the lower elevation. This map also shows the last old-growth areas. (Save the Redwoods.)

Usal Road runs from Chemise Mountain Road, through Four Corners, down to Usal. This road is not maintained during the winter and is very often impassable. It was used to travel from Usal up the coast and back down, but it was never improved. Now, most of the road is part of the Sinkyone Wilderness State Park. The stagecoach ran this route and through Four Corners. The above photograph shows the bridge over Usal Creek. The image below is from 1910. (Both, author's collection.)

Formed in 1986, the InterTribal Sinkyone Wilderness Council is unique in that it involves 13 Northern California tribes with a united mission. Its focus is to conserve and restore Sinkyone land in Mendocino and Humboldt Counties. The council has been able to restore thousands of acres back to the indigenous nations that once owned the land. It has also protected some of the few old-growth forests left. The council has been working with the Trust for Public Land to acquire more acreage. The council also works to restore the land and revitalize cultural traditions and values. This photograph dates from 1920. (Author's collection.)

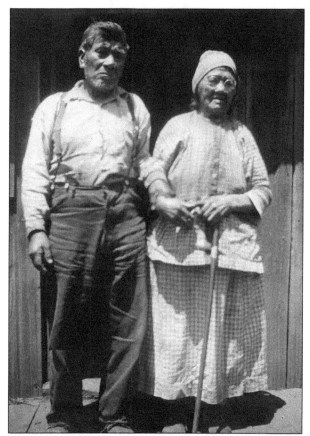

This photograph, taken July 1, 1949, shows Sally Bell and her husband, Tom (Coast Yukis). Sally witnessed and survived the massacre at Needle Rock in 1850. Malcolm Margolin quotes Sally in his book *The Way We Lived*: "They killed my grandfather and my mother and my father. I saw them do it." Sally Bell Grove, a strand of old-growth trees, was named for Sally. The photograph below shows the Needle Rock coastline today. (Left, Phoebe A. Hearst Museum of Anthropology; below, author's collection.)

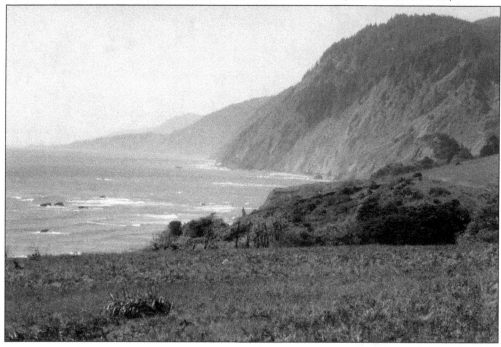

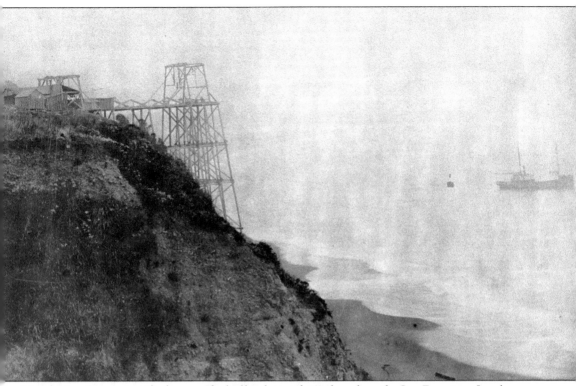

Mendocino County supplied a great deal of lumber and wood products for San Francisco. Lumber, ties, tanbark, and old-growth Douglas fir were all shipped from Needle Rock. In 1868, a chute was built at Needle Rock with a cable to get goods to the schooners. During the 1890s, this was a very active shipping point. This photograph, dated around 1900, shows the chute off the cliff at Needle Rock. (Kelley House Museum.)

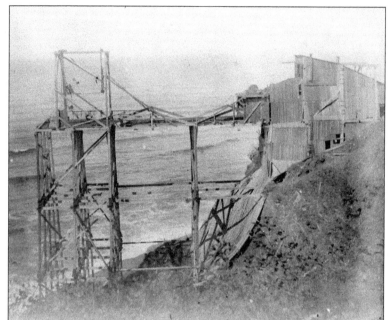

There were several chutes built at Needle Rock. This one was used mainly to ship ties and cords of tanbark by the Needle Rock Company. The chute was washed out in a storm in 1919. This photograph was taken in 1900. (Kelley House Museum.)

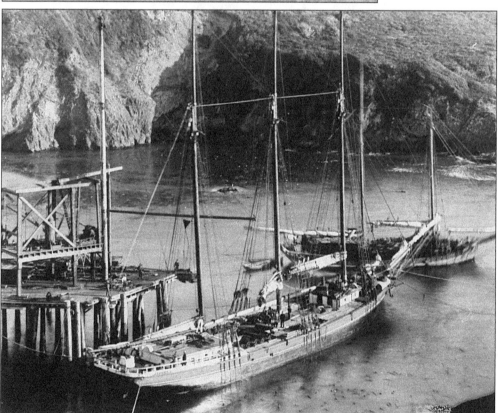

Ships would stop at Needle Rock and also Bear Harbor, which was only a few miles south of Needle Rock. This photograph shows two ships near the dock in the Needle Rock/Bear Harbor area. (Humboldt State University.)

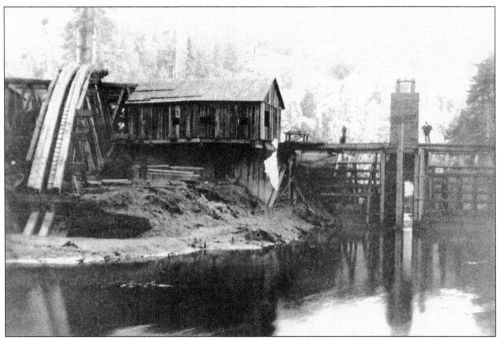

Calvin Stewart, who built the Mattole Landing, moved to Needle Rock in the 1920s. He is pictured here on top of the dam at Andersonia. Henry Neff Anderson was president of the Southern Humboldt Lumber Company. He had 15,000 acres from the ocean inland to Piercy. A dam was constructed on Indian Creek. (Kelley House Museum.)

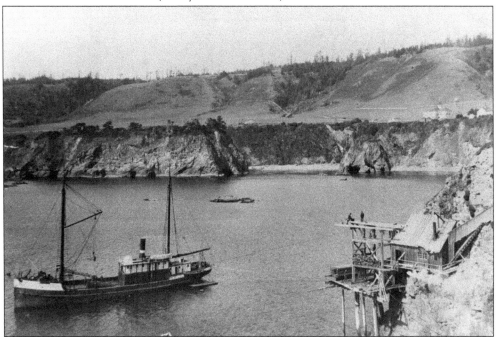

The *Alcazar*, pictured here at Cuffey's Cove, wrecked on the rocks at Needle Rock on June 10, 1907. It was partially loaded with railroad ties. The steamer struck low to the beach and, fortunately, all of the crew reached land. (Kelley House Museum.)

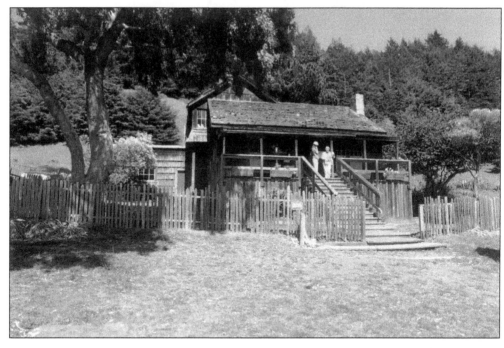

Calvin Stewart and his family moved to Needle Rock in 1921. His wife, Frances Eastman Stewart, taught at the Needle Rock School for 10 years. In the 1970s, all of the surrounding area became part of the Sinkyone Wilderness State Park. The Stewart home, pictured above, later became the Needle Rock Visitor Center. The top of Needle Rock fell during the 1906 earthquake. The photograph below shows how it looks today. (Both, author's collection.)

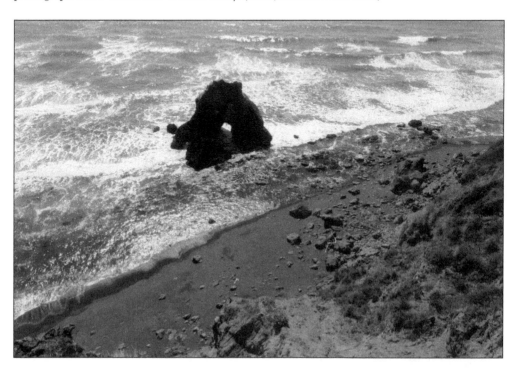

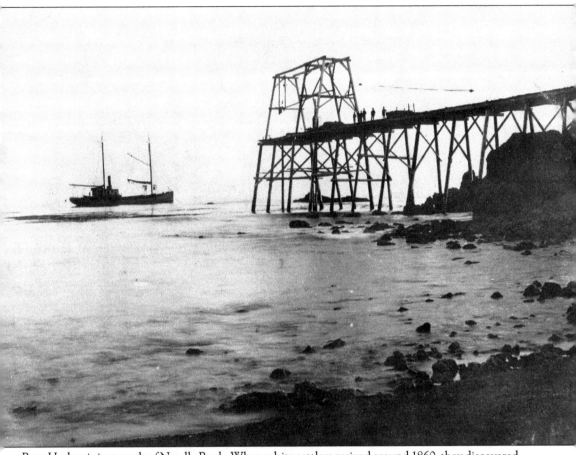

Bear Harbor is just south of Needle Rock. When white settlers arrived around 1860, they discovered that the Indian trails led to grassland ideal for grazing stock. Capt. John Morgan created a landing in 1868 and sold it. In 1884, a wharf and chute were built and, both were operational until 1885. Then, Len Barnard started a stagecoach from Westport to Bear Harbor, and it became a major shipping point. A railroad, school, and other buildings were constructed. A new wharf was built in the 1890s. It was 500 feet long and 40 feet high. The cove at Bear Harbor was shallow, so ships were unable to dock. The ships had to anchor a distance away and connect a cable to a steam donkey. The steam donkey then would power the cable to bring the bundled goods to the wharf, or vice versa. (Kelley House Museum.)

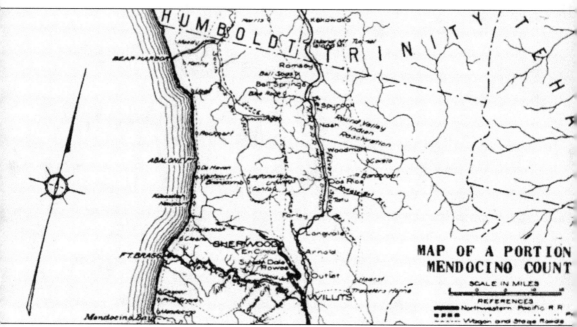

A railroad connected the wharf to the ridge above. It had a steep incline, so a gravity system was used. A winch lowered and raised the train and cars over a very steep stretch of the narrow-gauge track. Past Usal Road, the railroad ran on its own power. Later, the railroad was extended out about 10 miles and a small settlement developed called Moody. It had a hotel, general store, and a bar. That town no longer exists. In 1899, a large wave struck Bear Harbor, demolished the wharf, and ruined the railroad. Bear Harbor became a part of the Sinkyone Wilderness in the 1970s. (Author's collection.)

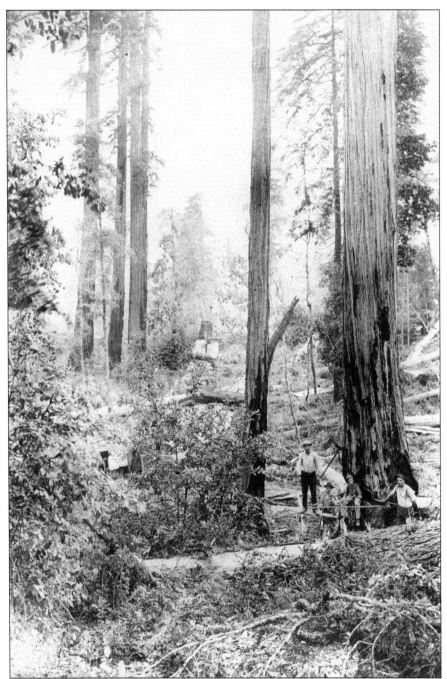

Three old-growth forests still exist within the Sinkyone Wilderness State Park: the J. Smeaton Chase Grove, School Marm Grove, and Sally Bell Grove. Chase Grove is named for Joseph Smeaton Chase, who was a trail rider and nature writer. The redwoods in this grove are twisted and gnarled, which probably saved them from being logged. School Marm Grove was so named as it was the site of a small red schoolhouse from long ago. There were 30 students in grades one through six. Sally Bell Grove is located near Usal. This photograph shows the Usal forest being logged in 1900. (Kelley House Museum.)

Save the Redwoods has been in existence since 1918. Founded by John C. Merriam, Madison Grant, and Henry Fairfield Osborn, it was inspired by Stephen Mather, first director of the National Park Service. It was further expanded by women in Humboldt County. (Author's collection.)

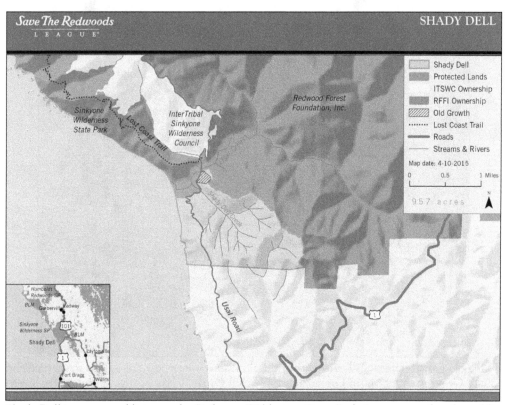

Shady Dell is a recent addition to the Sinkyone Wilderness State Park. It was opened to the public in May 2016. It is dedicated to Peter Douglas, a champion of preserving the coast. He helped write the Coastal Act of 1976. Shady Dell is located at the southern end of the Lost Coast Trail and showcases "candelabra" type trees. (Save the Redwoods.)

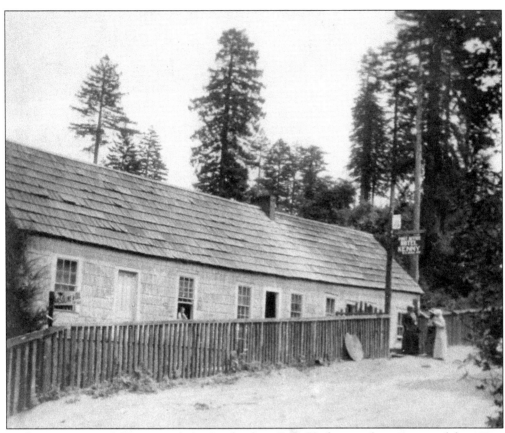

In the 1880s, Patrick Kenny settled 1.5 miles from Bear Harbor on the wagon road from Fort Bragg (Moody Road) and built a small hotel. Later, he built a saloon and stable. A post office was established in 1888 but closed in 1924. This photograph is from 1900. (Kelley House Museum.)

Kenny was located just off Usal Road, north of Wheeler. This photograph is from 1914. Now, all of these areas are ghost towns within Sinkyone Wilderness State Park. (Kelley House Museum.)

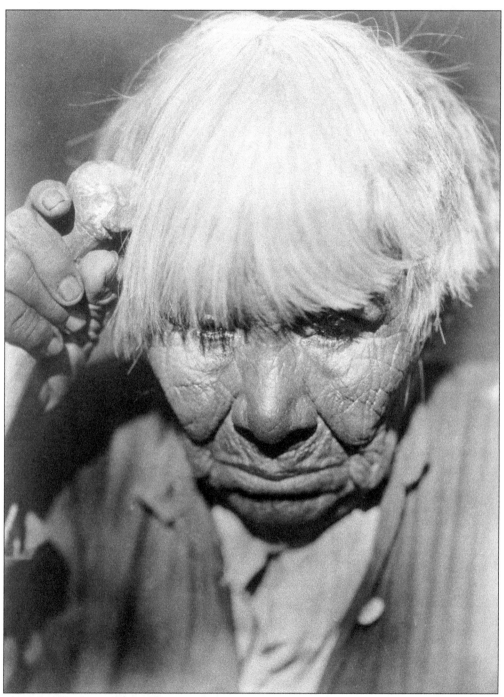

The lower Usal Creek area was used by the Sinkyones, the Cahtos, and the Coast Yukis. Both Coast Yuki and Sinkyone were spoken at Usal. The Coast Yukis called themselves Ookotontilka. This area had a bountiful old-growth redwood and Douglas fir forest with more than 18 creeks and tributaries. With abundant fauna, this was an important place for the Native Americans in the area. This photograph, titled *An old woman in mourning*, was taken by Edward S. Curtis in 1924. (Library of Congress.)

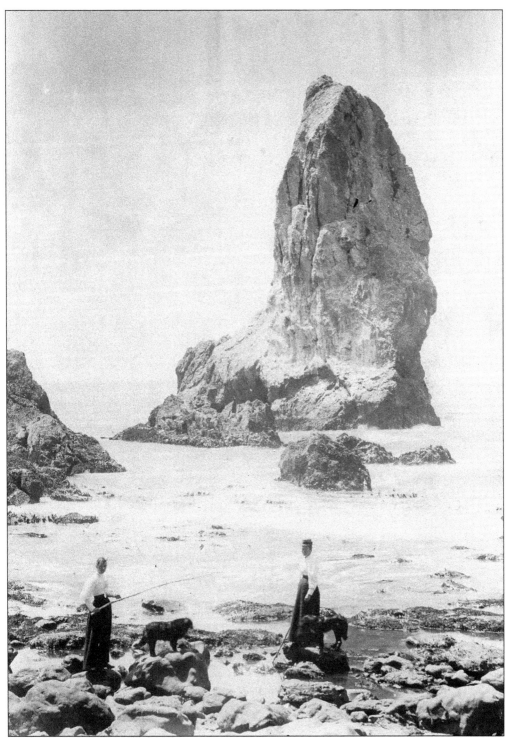

Usal has a very rich history regarding Native Americans. Usal Creek is the southernmost area where Sinkyone resided. This photograph of women fishing with their dogs was taken in 1897 by Fairbanks and DeBuhr. DeBuhr had a photograph studio in nearby Usal. (Kelley House Museum.)

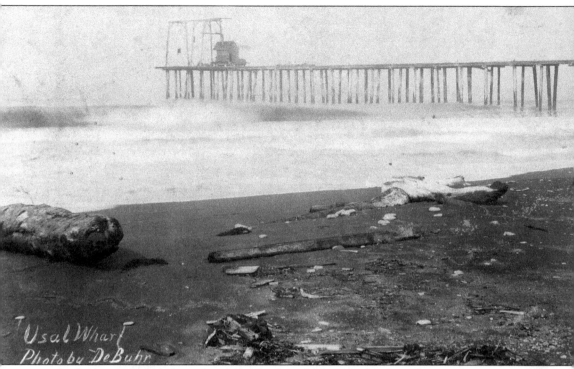

Usal Wharf
Photo by DeBuhr

In the late 1800s, Usal was discovered by those looking for lumber. The trees here were some of the largest. The Usal Lumber Company was formed in 1888 by T. Merrills (father and son) from Michigan. The next year, they sold the company to J.H. Wonderly. Desperate for places to load schooners, the Usal Lumber Company built a 1,400-foot-long wharf, and a town soon followed. This photograph is dated 1896. (Kelley House Museum.)

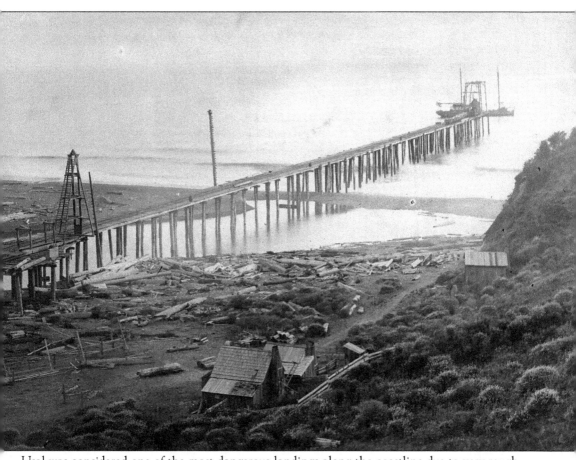

Usal was considered one of the most dangerous landings along the coastline due to very rough seas. Some ship captains did not want to land here. This photograph, from 1896, shows a boat waiting to be loaded at Usal Wharf. (Kelley House Museum.)

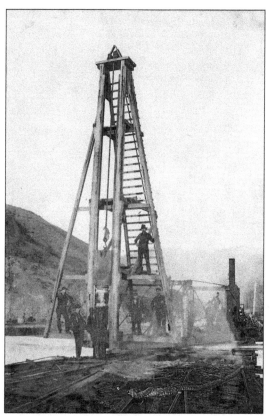

According to Mararite Cook and Diane Hawk in their book *A Glance Back*, Robert Dollar became the manager of the Usal Redwood Company in 1894. He purchased the ship *Newsboy*, a steam schooner, which he used to travel from Usal to San Francisco. Usually lumber companies did not own their own ships. Dollar was a very able captain of the ship. He later formed the Dollar Steamship Company, which became American President Lines. (Both, Kelley House Museum.)

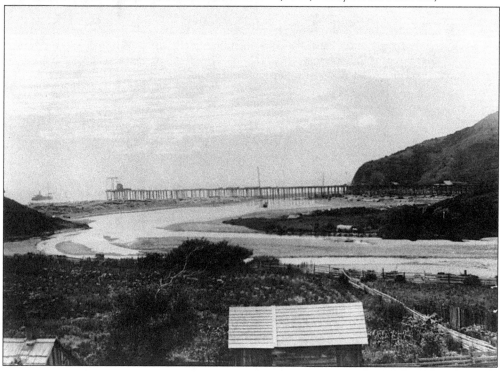

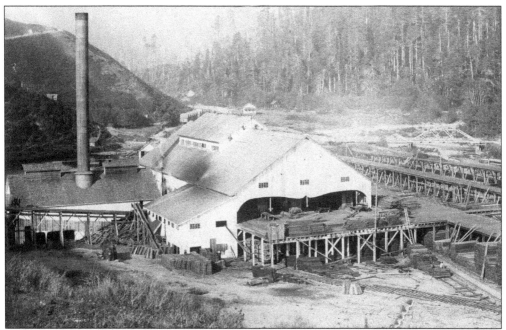

This photograph shows the Usal mill around 1896. The mill burned in 1902. Although the timber at Usal was large, some of it was damaged due to wind and decay. (Kelley House Museum.)

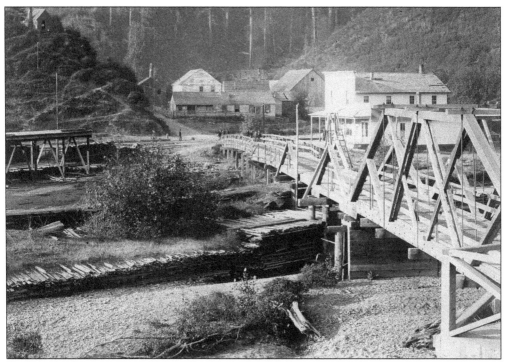

Usal grew rapidly. This 1896 photograph shows the bridge over Usal Creek. Capt. Robert Dollar lived in the white building next to the bridge. A cookhouse is in the back. (Kelley House Museum.)

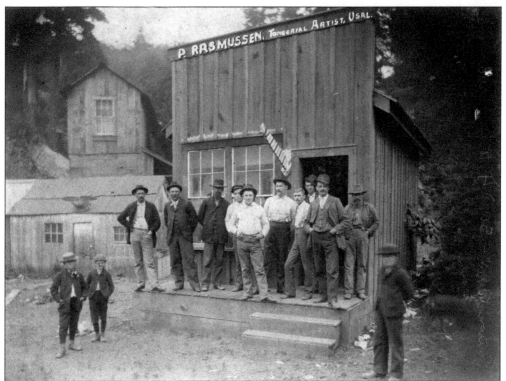

The town also had a hotel, photograph studio, store, school, and shops. Identified in this 1890 photograph is Pete Rasmussen (fifth from left on the porch, in white shirt) at his barbershop. This photograph was taken by A.O. Carpenter. (Kelley House Museum.)

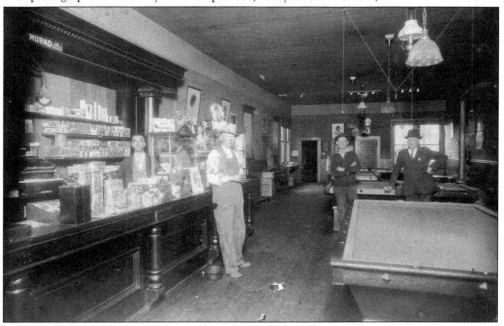

Usal also had a pool hall. Fred Rasmussen is shown here, with his uncle Fred behind the counter. This photograph is dated 1890. (Kelley House Museum.)

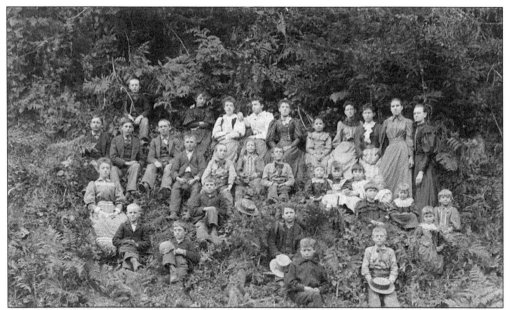

The Usal school opened in 1881. At the time, five students were in attendance. Enrollment grew to 35 students in 1891. Since there were so many mill workers and employees at other businesses, a school was needed. This photograph from 1896 shows students with the teacher, a Miss Deville. (Kelley House Museum.)

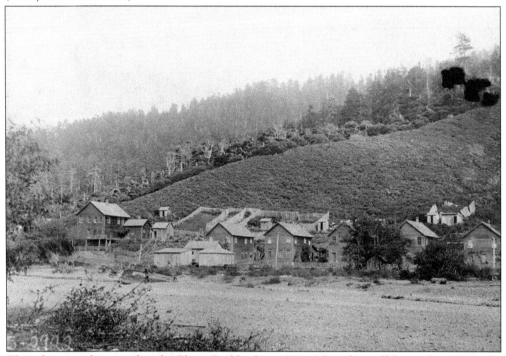

This photograph was taken by Pliny Goddard in 1902. After the mill burned in 1902, the town began to disintegrate. The wharf needed constant repair, and the timber output was not what was expected. The post office was moved the next year. (Phoebe A. Hearst Museum of Anthropology.)

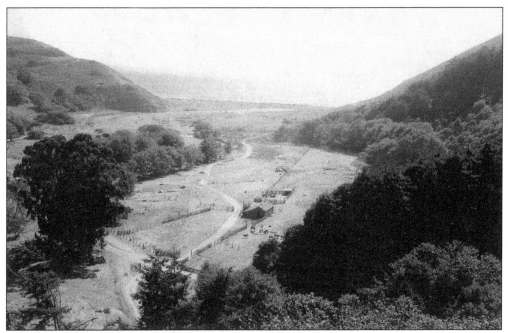

In later years, only a ranch and small store existed in Usal. Don Etter worked at the store in the 1940s. This photograph from 1966 shows the Usal ranch. (MVHS.)

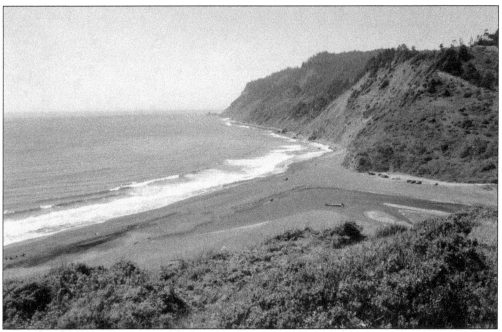

Usal became part of the Sinkyone Wilderness State Park in the 1980s. The dark sand beach about a mile long is now the southernmost beach in the park. It has a campground and is managed by the Bureau of Land Management. It is also the start of the official Lost Coast Trail heading north. The site has a primitive camping area, like most spots on the Lost Coast. (Author's collection.)

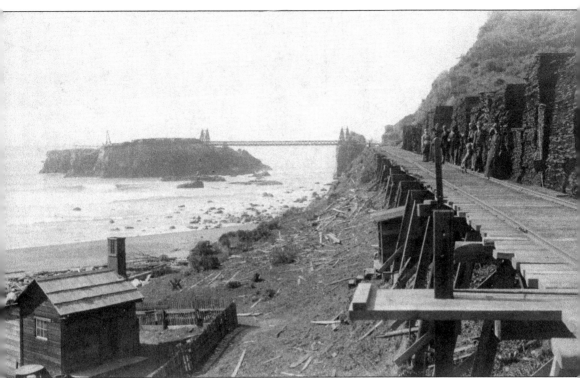

Rockport, south of Bear Harbor, was first called Cottoneva, as it was located on Cottoneva Creek. According to anthropologist Samuel Barrett, the Coast Yukis had many villages in the Cottoneva Creek area. In 1877, W.R. Miller constructed a suspension bridge connecting a small rock island to the shore. Miller had built a mill at Cottoneva Creek and needed a way to ship lumber. The rock island was leveled with sledgehammers until it was flat and a tramway was built. It is said to have been the first suspension bridge built on the North Coast. (Kelley House Museum.)

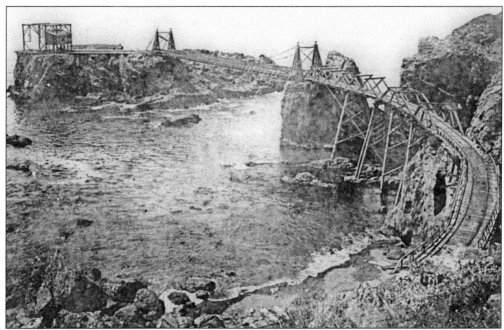

The suspension bridge jutted out over the water 275 feet to a small offshore island. The island was so small that only one man could work on it at a time. This photograph is dated 1879. (Kelley House Museum.)

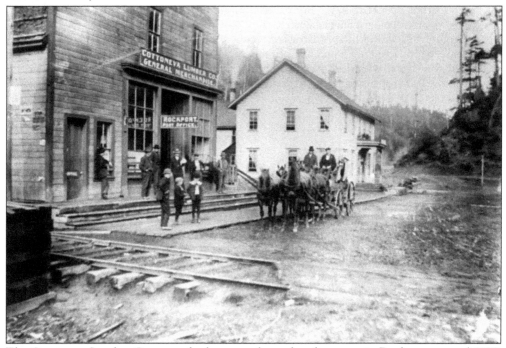

The Cottoneva Lumber Company had a general merchandise store in Rockport around 1899. There was also a post office from 1888 to 1903. The lumber company struggled, then the mill caught fire. Rockport was revived in 1925 with a series of new owners and thrived until 1942 when the mill burned to the ground. (Kelley House Museum.)

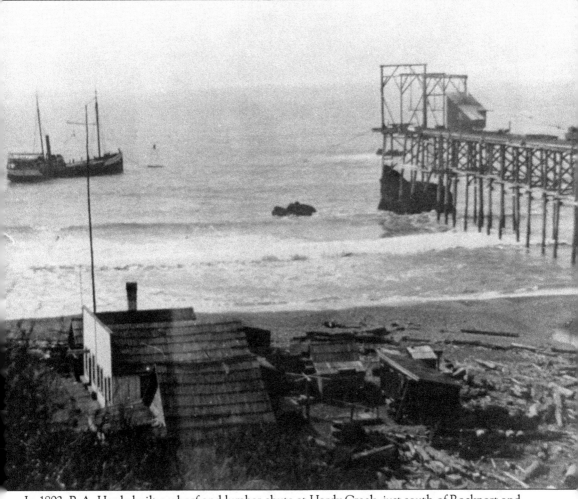

In 1892, R.A. Hardy built a wharf and lumber chute at Hardy Creek, just south of Rockport and about seven miles north of Westport. The wharf was 590 feet long with a wire chute at the end. The Hardy Creek Lumber Company was formed in 1896. Tanbark and split stuff were shipped. This photograph, taken in 1910, shows a ship being loaded with lumber. The saloon, operated by Carl Colberg, is on the left side of the beach. (Kelley House Museum.)

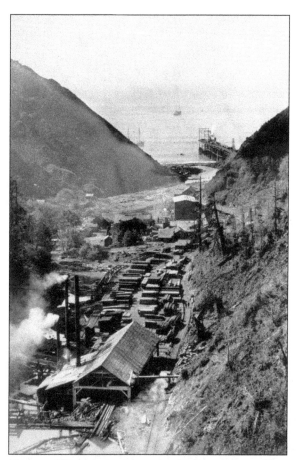

The photograph at left shows the mill at Hardy Creek around 1910. The mill burned in 1912 and was never rebuilt. The photograph below shows the Hardy Hotel around 1910. A lumberyard is to the right. (Both, Kelley House Museum.)

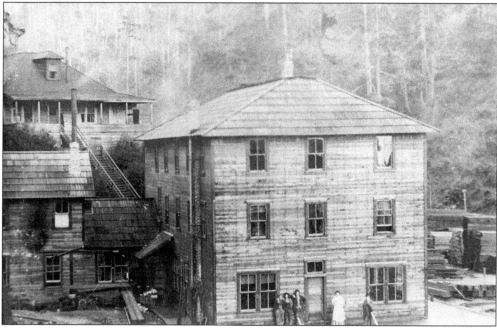

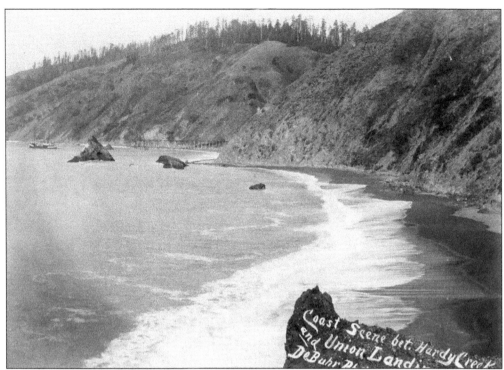

The Coast Yukis lived in a village called Shipoi, near where the current town of Westport is located. Most experts agree that Yukis occupied the coastline from Cleone north, including many villages in the Westport and Rockport area. According to Thad M. Van Buren in his book *Belonging to Places*, five housepits and part of a Native American assembly hall were still present in Westport in 1920. Anthropologist Edward Gifford interviewed the Yukis in 1920. In the late 1800s, Westport was referred to Beall's Landing. The above photograph shows the coast between Hardy and Union Landing around 1900. There is a long wharf in the distance. The photograph below is of a family at the beach in the Westport area in the 1880s. (Both, Kelley House Museum.)

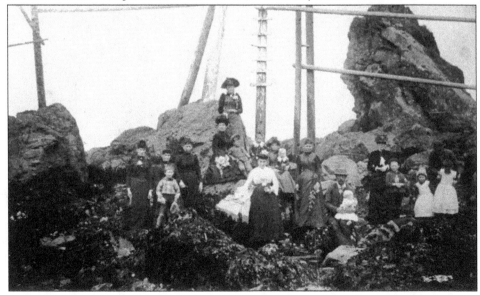

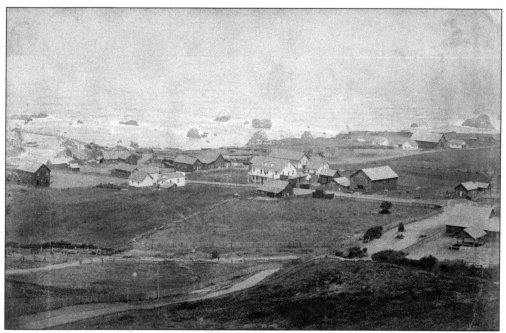

This photograph shows Westport in 1870. Although the rocky coast was a challenge for shipping, overland travel was more difficult due to lack of roads. Mooring was extremely hard as harsh winds blew ships into the rocks, especially at Westport. Complicated loading and unloading systems were developed. According to Thad M. Van Buren in his book *Belonging to Places*, 292 million shakes/shingles were shipped from 1878 to 1880 along with fence posts, tanbark, and firewood. (Kelley House Museum.)

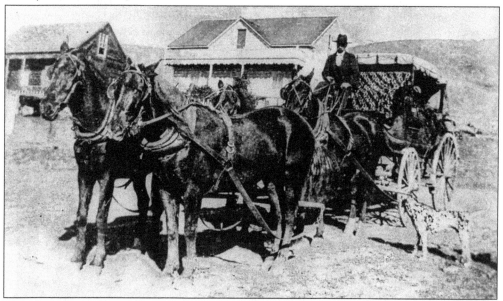

This photograph shows the stage arriving in Westport. Henry Little drove the stage that ran from Fort Bragg to Westport. It also carried the mail. This photograph, which includes Henry's dog, was taken on May 2, 1889. Another stage, from Westport to Mendocino, was operated by Len Bernard. That stage was later extended to Bear Harbor in 1887. (Kelley House Museum.)

124

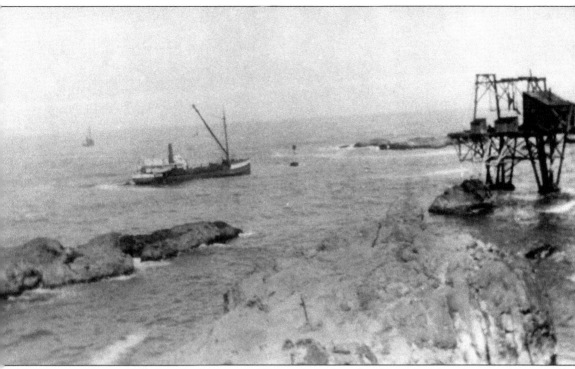

In Westport, James T. Rodgers built a pier in 1878 and another wharf in 1882. This photograph, from 1890, shows railroad ties being loaded by a wire chute. These settlers had to be inventive in the ways they loaded and unloaded due to the rough conditions. Rodgers received a patent for a shackle used with cables. Lumber would be damaged if thrown into the ocean so it had to handled gently. Although the chutes look frail, they did not have to bear too much weight as the lumber was slid down planks or hoisted with cables. (Kelley House Museum.)

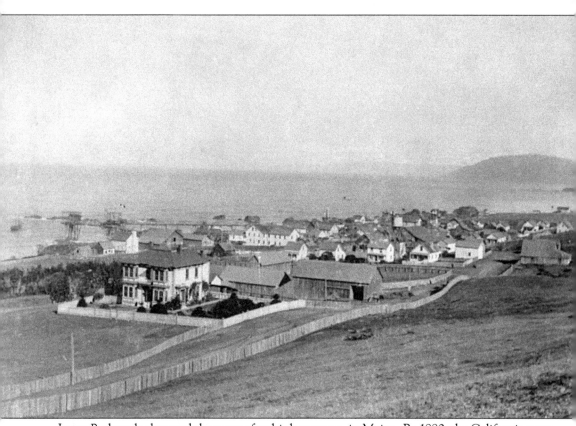

James Rodgers had named the town after his hometown in Maine. By 1880, the California town had a store, two hotels, and a livery. In 1895, Thad Van Buren reports in *Belonging to Places* that there were 18 saloons, 4 hotels, and 2 brothels. By 1900, Westport had reached its peak population. This photograph shows the town in 1900. (Kelley House Museum.)

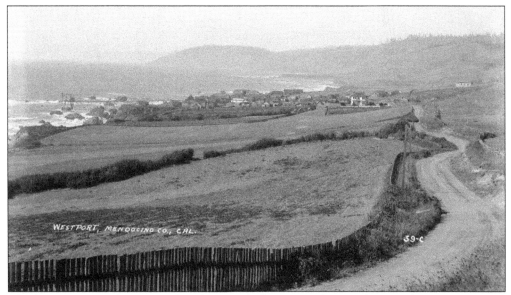

The Switzer House dominates this photograph from 1920 that was later made into a postcard. Although the 1906 earthquake caused a demand for redwood to rebuild the city, most of Westport's timber had already been utilized. The timber supply was depleted by 1914, and all of the mills shut down. A railroad was developed from Wages Creek to Westport to ship split stuff and ties, but Westport mainly relied on the local businesses, such as stores, saloons, brothels, and hotels for people in the outlying areas. (Kelley House Museum.)

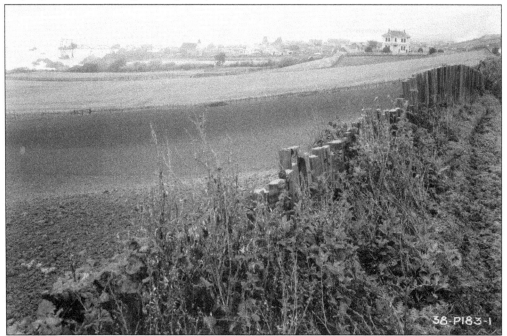

Photographer Roger Sturtevant, as part of the Historic American Buildings Survey, took this photograph of Westport in 1934. It looks very similar today. Westport now, with its weathered wooden cottages and small-town charm, is the perfect example of a coastal town along the highway that leads to the Lost Coast. (Library of Congress.)

Visit us at
arcadiapublishing.com

Printed in the USA
CPSIA information can be obtained
at www.ICGtesting.com
LVHW080805210823
755799LV00006B/12

9 781540 215314